Chinese Calligraphy Made Easy

Chinese Calligraphy Made Easy

A structured course in creating beautiful brush lettering

Rebecca Yue

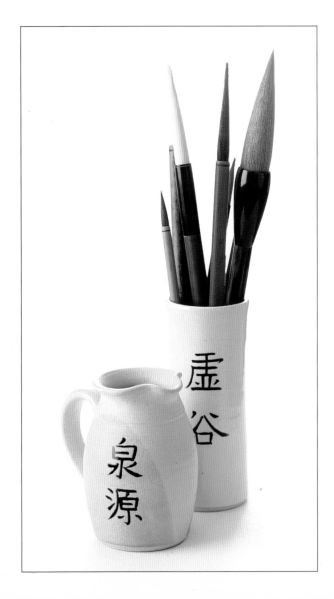

An imprint of Watson-Guptil Publications
New York

First published in the USA in 2005 by
Watson-Guptill Publications
A division of VNU Business Media, Inc.,
770 Broadway
New York, NY10003
www.watsonguptill.com

First published in Great Britain in 2004
by Collins & Brown Limited

An imprint of **Chrysalis** Books Group

The Chrysalis Building
Bramley Road
London W10 6SP
www.chrysalisbooks.co.uk

1 3 5 7 9 8 6 4 2

CIP Catalog Control Number: 2004104323.

ISBN: 0-8230-0556-9

Designer: Lisa David
Photographer: Sian Irvine
Illustrator: Juliet Percival
Copy Editor: Chris George
Project Editor: Serena Webb

Reproduction by Anorax, Leeds, UK.
Printed and bound by Kyodo Printing Co Pte Ltd, Singapore

Contents

Five: The Five Golden Rules — 96

Six: The Five Styles of Chinese Calligraphy 112

Mounting a Xuan Paper Artwork 132

Gallery 138

Glossary 152

Suppliers, Index, and Acknowledgments 156

Introduction

The Chinese language has no alphabet. Instead of comprising letters, each Chinese word is made up of many basic brushstrokes. This written language has evolved over 4,000 years, during which many different styles of calligraphy have been developed. Each of these scripts is closely associated with a certain period in the history of China. Among all the styles, five have been the most influential and are still in use today.

The form of each word differs from style to style. Even within one style, certain words may have many forms because scholars have come up with different ways of expressing each word over the centuries.

"Shu" is the Chinese word for writing. It is the Kai Shu style that is used for the Chinese dictionary. Kai Shu is also the style of writing learned by young children in school and beginners in calligraphy. Printed documents and books use a variation of Kai Shu. Hsing Shu is the style of writing most people use for personal communication. The other three styles are generally more popular with modern artists.

In order to understand these styles, it is worth looking briefly into the history of Chinese calligraphy. Each style began developing long before it became popular, and it was usually a particular political situation that allowed a style to become dominant.

The different techniques used for writing the five styles are covered in detail in Chapter Six (see page 112).

Chuan Shu

Chuan Shu is the oldest of the five principal styles of Chinese calligraphy. It was first used as early as 1900 B.C. and continued to dominate through to the early Qin Dynasty (221–207 B.C.). The earliest artifacts we have using this style date back to the Shang Dynasty (1700–1027 B.C.).

Between the Shang and Qin dynasties, there was the Zhou Dynasty (1027–476 B.C.). During the later part of the Zhou period, China was split into many warrior territories. The rule of each warrior was short, and the political turmoil meant there was no uniform development of calligraphy. Chuan Shu was widely used, but expressions and forms differed from kingdom to kingdom. Writing was mainly for ceremonial purposes— usually inscribed or painted on memorial tablets and sacrificial utensils, for use in palaces and temples—and messages were usually short. Painted pots from this era indicate a form of brush was used, though the proper modern version of a brush was not invented until around 250 B.C. by a man called Meng Tian.

Throughout the history of China, and even today, seals have been traditionally engraved using Chuan Shu.

Li Shu and Tsao Shu

The emperor of Qin unified China in 221 B.C. He set out to bring order to China—laws were made, carefully recorded, and strictly followed. Chuan Shu was used at the beginning of the emperor's rule; however, it proved to be very difficult to learn, and it was soon apparent that Chuan Shu simply could not cope with the rapid increase in official record-keeping.

Li Shu and Tsao Shu, though not fully developed, became the new styles. They were simpler to learn, easier to recognize, and quicker to write. Gradually, both styles started to be used in documents. Li Shu, however, being easier to read and write than Tsao Shu, soon became the official style. The invention of brushes encouraged ordinary people to start using writing in their daily lives. However, as paper had not yet been invented, bamboo slats were widely used to write on.

The emperor was obsessive about recordings. Imagine the amount of bamboo slats the officials had to carry around! The practice was to squash as many writings as possible onto a slat, which in turn greatly transformed the structure of Li Shu writing. It is also useful to note that although Li Shu was official, it was not considered to be the proper style for use in sacrificial and memorial writings. Chuan Shu remained the style to be used for such purposes.

Kai Shu and Hsing Shu

The Han Dynasty that followed (206 B.C.–A.D. 220) was a prosperous and stable period. No longer limited to ceremonial and official use, calligraphy began to develop into an art form. Li Shu remained the favorite style as early forms of Kai Shu and Hsing Shu began to appear. Not yet well developed, these new scripts offered alternatives to scholars, who were hungry for new means of expression.

Paper was invented during this time, replacing bamboo slats and making writing even more popular.

After Han, China plunged into another unstable period. Although briefly unified by the Wei Dynasty (A.D. 220-265) and the Jin Dynasty (A.D. 265–420), China was constantly plagued by northern nomadic tribes and split into many kingdoms. It was during this troubled time that the genius calligrapher Wang Xi Zhi (A.D. 303–361) was born. He popularized Hsing Shu, which had now become a fully developed style. He also specialized in the small script of Kai Shu, his writings of which became the model for later generations.

Most importantly during this period, calligraphy became a part of everyday life. Scholars and artists used it for art, officials used it for record-keeping, and it became more common for ordinary people to write.

The golden age of calligraphy

The Tang Dynasty (A.D. 618–907) was one of the most glorious times in the history of China. Prosperous, stable, and hungry for art, this period provided a perfect ground for calligraphy to thrive. Society placed great emphasis on art and literature, so competition between scholars became fierce, and quality rose to the highest standards.

Kai Shu, with its precise and elegant style, immediately became the favorite among scholars. With so much support, the Kai Shu script was recorded in detail. Instructions for writing every brushstroke were passed down for posterity—no other style of calligraphy enjoyed such attention. These ancient records have become the standard for learning calligraphy today.

By the end of the Tang Dynasty, all five major styles of calligraphy were developed. Hsing Shu remained the people's style; however, artists and scholars continued to make use of and excel in all the styles, according to individual taste. The emperors of the major dynasties that followed—Song, Yaan, Ming, and Qing—tended to be scholars rather than warriors, so the art of calligraphy continued to flourish.

Chinese calligraphy today

In modern times, Hsing Shu is still the style for daily communication, although the majority of Chinese would not know in which style of calligraphy they were writing. They would, however, recognize Kai Shu because all textbooks are printed in this style. In general writing, everybody uses Hsing Shu or a mixture of Hsing Shu and Kai Shu. There is a trend to revive all styles for artistic purposes, and many schools and guilds are now springing up in China, each specializing in a particular style. Scholars continue to develop the art of calligraphy, and many beautiful works are being produced.

About this book

It was Kai Shu that laid down the standard for constructing brushstrokes. Each style of calligraphy uses these standard brushstrokes and their variations to construct words in the way that suits the style. You must therefore learn the brushstrokes in the Kai Shu style to begin learning Chinese calligraphy. Since Hsing Shu is the modern dominant style, it is appropriate for you to learn to write in this style. In order to achieve both, each lesson will have instructions on a brushstroke in Kai Shu style followed by constructions of words in the Hsing Shu style. So all the words you will learn will be Hsing Shu.

In order to write Chinese beautifully, you must learn to choose, use, and properly care for your brushes. This is therefore explained before the practical lessons begin.

The writing process begins with learning how to control the movement of a brush using the wrist and elbow, in conjunction with lift and press techniques. These are explained in Chapter Three. Once equipped with these techniques, you will be able to learn all eight of the basic brushstrokes, one by one, in the lessons that follow. With each new brushstroke there are words to practice; each has been carefully chosen, with its English meaning beside it, not only to use the new stroke but also to revise those already learned.

If you follow all the lessons, one after another, you will build up a collection of Chinese words, starting with simple structures and working up to more complicated compositions. At intervals there are sheets of additional words so you can practice what you have learned so far.

There are also projects for you to try out your newfound skills. They are designed not only to help you enjoy calligraphy, but to give you an insight into the traditional uses of this ancient art.

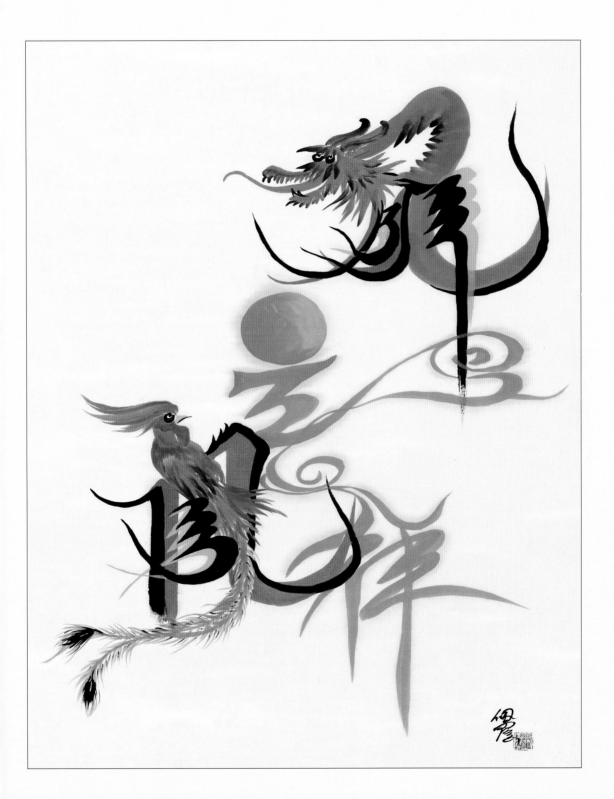

One
Materials and Equipment

The essential requirements for Chinese calligraphy are brushes, paper, and ink. Each needs to be chosen with care to ensure that they are specifically designed for this form of writing.

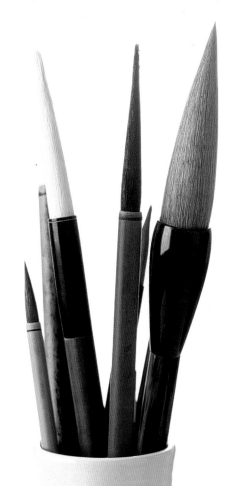

Brushes

A Chinese brush consists of a handle and a brush tip. The handle is traditionally made of bamboo, while the tip is made of animal hair, classified by the color that it is dyed. In general, white hair is soft, brown hair is stiffer, and black hair is the firmest.

Some brushes are designed for painting and some for calligraphy—although brushes for general use do exist. In calligraphy, the size of the brush used depends on the size of the words being written. The three main script sizes are as follows:

Words occupying an overall space of 1 x 1 in (2.5 x 2.5 cm) or less are called
"Small Script" 小楷

Words larger than 1 x 1 in (2.5 x 2.5 cm) are called
"Large Script" 大楷

Very large words are called
"Big Writing" 大字

The defining line between Large Script and Big Writing is not clear, but it falls somewhere between 2 x 2 in (5 x 5 cm) and 3 x 3 in (7.5 x 7.5 cm). Calligraphers disagree about the actual measurements of the different sizes, but the issue is not important. Generally, small words should be written with small brushes and big words with big brushes.

The simplest way to to check you have the right-sized brush is to try it out. If you feel the brush is stretched for your intended script size, change to a bigger one. If you feel your brushstrokes are getting too big and out of control, change to a smaller one. My teachers trained me to keep an open mind about choosing brushes for different sizes and styles of writing.

I usually tried various brushes and chose according to how I felt. However, it is useful for beginners to have some general guidelines. Please note that the appearances of some of the brushes shown here may be slightly different to those you find.

White-hair brushes

White-hair brushes use goat hair, lambswool, goose feathers, or chicken feathers. Calligraphers favor soft-hair brushes because they can carry more ink to sustain the writing, especially for Large Script. I prefer those made of goat's hair 羊毫.

These brushes are further classified by the length of their tips:

short tip 宿鋒

long tip 長鋒 and

extra long tip 特長鋒.

Long-tipped brushes offer more flexibility than short ones, but they are more expensive. I advise beginners to start with short brushes, progressing to long ones when they become more experienced.

Short and long brushes are available in three sizes: small, medium, and big. The small ones are for writing Small Script and the big ones for Large Script. The medium-sized brushes are versatile enough to be used for both Small and Large Scripts.

Extra long brushes are for Big Writing and expressive calligraphy, like that using the Tsao Shu style.

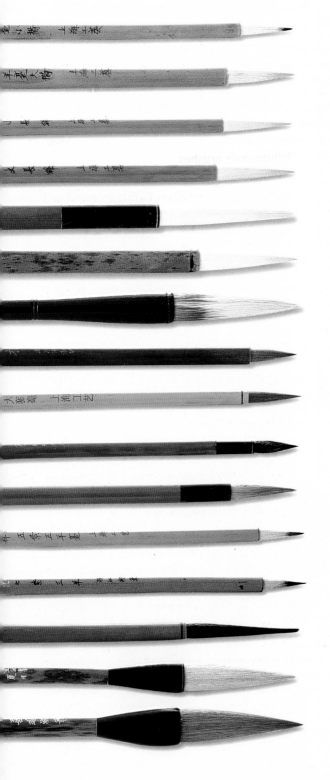

1. Short tip, goat's hair, Small Script

2. Short tip, goat's hair, Large Script

3. Long tip, goat's hair, Small Script

4. Long tip, goat's hair, Large Script

5. Extra long tip, goat's hair

6. White crane spreading its wings

7. White goose

8. Short tip, wolf's hair, Small Script

9. Short tip, wolf's hair, Large Script

10. Long tip, wolf's hair, Small Script

11. Long tip, wolf's hair, Large Script

12. 50% rabbit's hair, 50% goat's hair

13. 70% rabbit's hair, 30% goat's hair

14. Imitating the style of Song

15. Goat's hair Ti brush

16. Wolf's hair Ti brush

Here is a list of goat-hair brushes with their proper Chinese names:

宿鋒羊毫大楷
Short tip, goat's hair, Large Script

宿鋒羊毫中楷
Short tip, goat's hair, Medium Script

宿鋒羊毫小楷
Short tip, goat's hair, Small Script

長鋒羊毫大楷
Long tip, goat's hair, Large Script

長鋒羊毫中楷
Long tip, goat's hair, Medium Script

長鋒羊毫小楷
Long tip, goat's hair, Small Script

特長鋒羊毫
Extra long tip, goat's hair

Two other popular but expensive soft-hair brushes made for Big Writing are:

白 我鳥
White goose

白 鶴展翼
The white crane spreading its wings

Brown-hair brushes

Brown-hair brushes come from animals such as foxes, wolves, and rabbits. They are often called tough-hair brushes and are firmer than white-hair brushes. They are best for general painting, though some are designed for writing as some calligraphers like their stiffness,

especially for writing Small Script. The brushstrokes of Small Script are thinner and need firmer brushes to give them strength. I have used a selection of brushes made of wolf's hair 狼毫 for calligraphy.

狼毫大楷
Wolf's hair, Large Script

狼毫中楷
Wolf's hair, Medium Script

狼毫小楷
Wolf's hair, Small Script

長鋒狼毫大楷
Long tip, wolf's hair, Large Script

長鋒狼毫中楷
Long tip, wolf's hair, Medium Script

長鋒狼毫小楷
Long tip, wolf's hair, Small Script

Although soft brushes are generally used for writing bigger scripts, many calligraphers prefer the long-tipped, wolf-hair brushes for writing Large Script when using the Hsing Shu and Tsao Shu styles. These scripts are written faster than other styles, and wolf-hair offers the required firmness.

Black-hair brushes

There are brushes made of even firmer hair, usually colored black, and sourced from animals such as hogs, horses, squirrels, and racoons. These brushes are generally expensive. They carry little moisture and are best for expressive work that requires a dry effect. There is no short version of this type of brush, only long tips and extra-long tips. Handles for these brushes are usually longer than usual to allow for the

elbow to be swung for expressiveness. Many black-hair brushes are made for painting, particularly landscapes and animals, but a few are made for calligraphy. One such brush is known as "imitating the style of Song" 仿古宋筆.

Be warned: many brushes made for the tourist industry are dyed black in order to make them more attractive. These are not the firm brushes I am referring to. Insist on finding out the kind of hair your brushes are made of.

Other types of brush

Some brushes use a mixture of soft and tough hair. The more popular ones made for calligraphy are as follows:

五紫五羊　50% rabbit's hair, 50% goat's hair

七紫三羊　70% rabbit's hair, 30% goat's hair

三紫七羊　30% rabbit's hair, 70% goat's hair

These are all brushes for writing Small Script. The brush tip is made of soft hair wrapped around a tiny bundle of stiff hair, which extends to form the nib. The stiff hair enables you to write Small Script, while the soft hair holds the ink.

These are all good brushes, but every teacher has his or her preference. I usually advise my pupils to use the ones with a 50/50 rabbit-and-goat-hair mix.

Mixed-hair brushes are only popular for writing Small Script. Writing larger script requires more ink, so soft-hair brushes are used.

Finally, in every category, there are brushes with very big tips. They are called **Ti brushes** 提筆 and are used for big and expressive writings.

A beginner's kit

I recommend the following brushes to get you started:

For Small Script:

Short tip, goat's hair, Small Script, plus
Short tip, wolf's hair, Small Script, or
50/50 rabbit-and-goat hair

In this book, these are referred to as small brushes. You really only need the short tip, goat's hair brush for the learning process. However, I have included two brushes because I want you to try both when writing Small Script, so you can discover the difference and your preference. Another reason for including two was in case you are writing very small Chinese words, in which case it is better to use a stiffer brush.

For Large Script:

Short tip, goat's hair, Large Script, or
Long tip, goat's hair, Large Script

These are referred to as large brushes in this book.

You can start writing the words in this book with the goat's hair Small Script brush. When you are used to writing with this brush, try a Large Script one. Learn to feel how the brush performs. If it works for you, continue to use it. If it is too big, either go back to the Small Script brush, or try to write bigger words.

Paper

Traditionally, a special absorbent type of paper is used for calligraphy, known as Xuan paper 宣紙 *.*

The Chinese, the Japanese, and the Koreans all make Xuan paper, which is sold in loose sheets or continuous rolls. It is available in four different thicknesses:

one sheet 單宣
two sheet 雙夾宣
three sheet 三夾宣
and four sheet 四夾宣

One sheet and two sheet are suitable thicknesses for calligraphy.

An ideal paper to start off with is "Moon Palace" 月宮殿 . This was the name originally given to Xuan paper made to a Japanese formula, although it is now available from Chinese and Taiwanese manufacturers.

"Moon Palace" has a two-sheet thickness and is widely available; any art shop can order it for you. It has a smooth side and a rough side. It's better to write on the smooth side (although some calligraphers insist the rough side is more suitable).

Absorbent paper made of **cotton** 棉紙 is also becoming very popular and is a personal favorite of mine for both painting and writing.

Cheaper, more absorbent paper is available for practicing calligraphy. Usually yellow or light brown in color, some of these practice papers are printed with grids of nine squares. These grids are designed to guide you with the proportions of brushstrokes, and they are used in conjunction with samples printed on a grid. You can also use newsprint for practice.

Decorative papers

The Chinese frequently use decorative paper for calligraphy. These include mulberry paper with its beautiful texture, speckled paper with bits of gold paper embedded in it, and red paper or gold paper, which is popular for festive occasions. Paper can also be printed with patterns symbolizing such things as luck, blessings, dragons, and long life.

Other writing materials

Although we traditionally use absorbent paper for Chinese calligraphy, there is no reason why you should not experiment with other types. Sugar paper, writing paper, craft paper, card of different thicknesses, and paper for painting can all be used for Chinese calligraphy artworks. When you are writing on non absorbent paper, make sure you fully load your brushes with ink and press harder to write.

Calligraphy artworks can be created on almost any surface, including fabric, wood, pots, and tiles.

"Moon Palace" (left) is a type of Xuan paper. Widely available, the paper has a smooth and a rough side.

Decorative paper printed with patterns (right) that symbolize good wishes and luck are very popular with calligraphers.

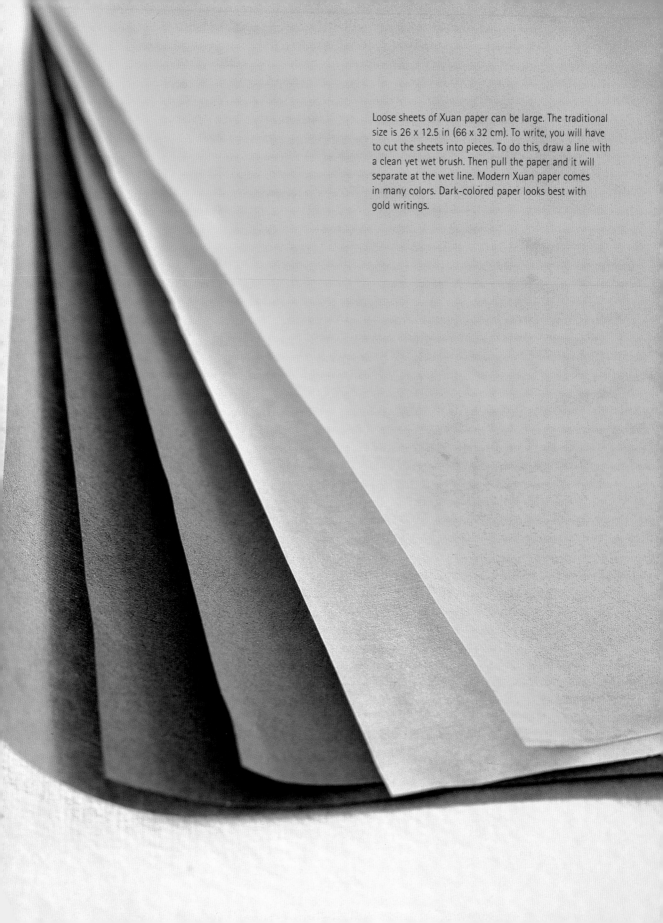

Loose sheets of Xuan paper can be large. The traditional size is 26 x 12.5 in (66 x 32 cm). To write, you will have to cut the sheets into pieces. To do this, draw a line with a clean yet wet brush. Then pull the paper and it will separate at the wet line. Modern Xuan paper comes in many colors. Dark-colored paper looks best with gold writings.

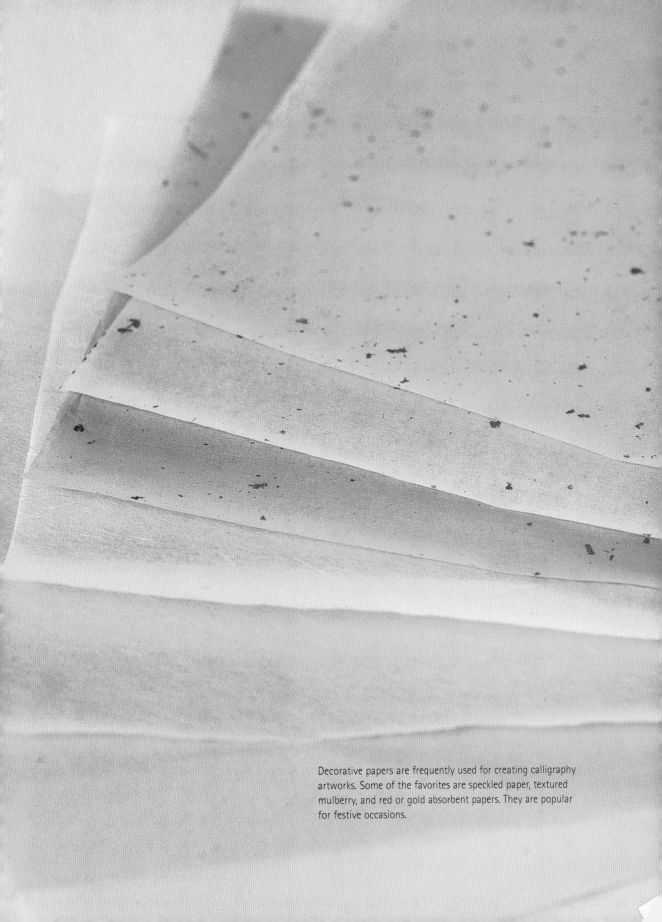

Decorative papers are frequently used for creating calligraphy artworks. Some of the favorites are speckled paper, textured mulberry, and red or gold absorbent papers. They are popular for festive occasions.

Ink and Other Accessories

I used to insist that my pupils made their ink by grinding ink sticks on inkstones because quite a few years ago the quality of premixed liquid ink was very poor. The only way to get dark, thick ink, therefore, was by grinding ink sticks with water. This is still the best way to make good quality ink. However, the quality of bottled liquid ink has greatly improved and is more than acceptable—especially when considering the convenience.

Western writing ink is not suitable for writing on absorbent paper because it runs. Chinese ink has gum in it and becomes permanent on paper as it dries. It will also stain material, so it is advisable to wear old clothes.

The liquid ink I recommend is made by 一得閣, the oldest ink-maker in China—it is the best quality ink.

When ink is first poured out of a bottle it is quite thin, but it will quickly thicken up when left out in the open. I usually leave it for 5–10 minutes before using it. If the ink is left for much longer, it becomes too thick for writing. If this happens, add a little bit of fresh ink to thin it out: do not add water, as this will make the ink paler.

You usually only need to pour out a small amount of ink at a time. When writing Small Script you will require very little—you will need more with bigger scripts.

Although an inkstone is traditionally used for grinding an ink stick to make ink, you can use it as a reservoir for the liquid ink. Make sure you clean the stone properly every time you use it, as any dried-up ink will damage the finely abrasive stone. If you do not have an inkstone, a small ceramic dish will be fine.

Colors

You can use most kinds of paint for writing, though ink is the traditional medium. Watercolors, acrylics, poster paints, and other water-based paints are suitable for artistic presentations of Chinese calligraphy. You cannot, however, write brushstrokes properly with oil-based colors.

Other accessories

You will also need the following:

- A big jar or yogurt container for cleaning your brushes
- Lots of newspaper to protect your writing surface
- A piece of large clean newsprint to rest your writing paper on if you are using absorbent paper, to soak up extra moisture. Change the newsprint when it gets too wet and dirty. Most art shops stock newsprint (the type of thin paper that newspapers are usually printed on).
- Some weights, such as small stones or paperweights, to prevent your paper from moving while you are writing
- A mixing dish if you are using colors

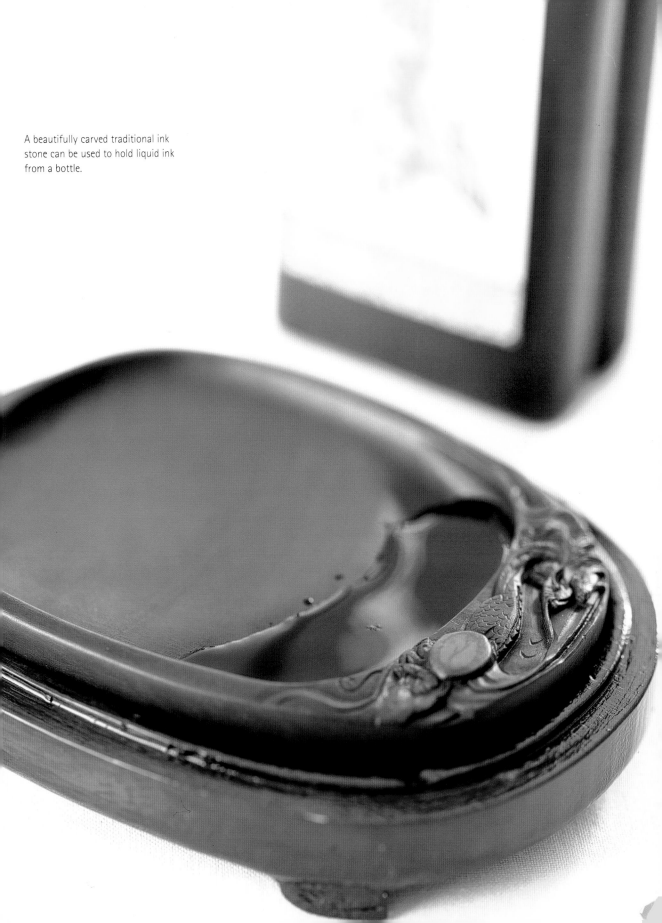

A beautifully carved traditional ink stone can be used to hold liquid ink from a bottle.

Two
Preparation

These first two lessons are designed to teach newcomers to calligraphy what to do with their brushes. Discover how to "open" a brush for use, how to keep it in top condition, and how to hold it properly when writing.

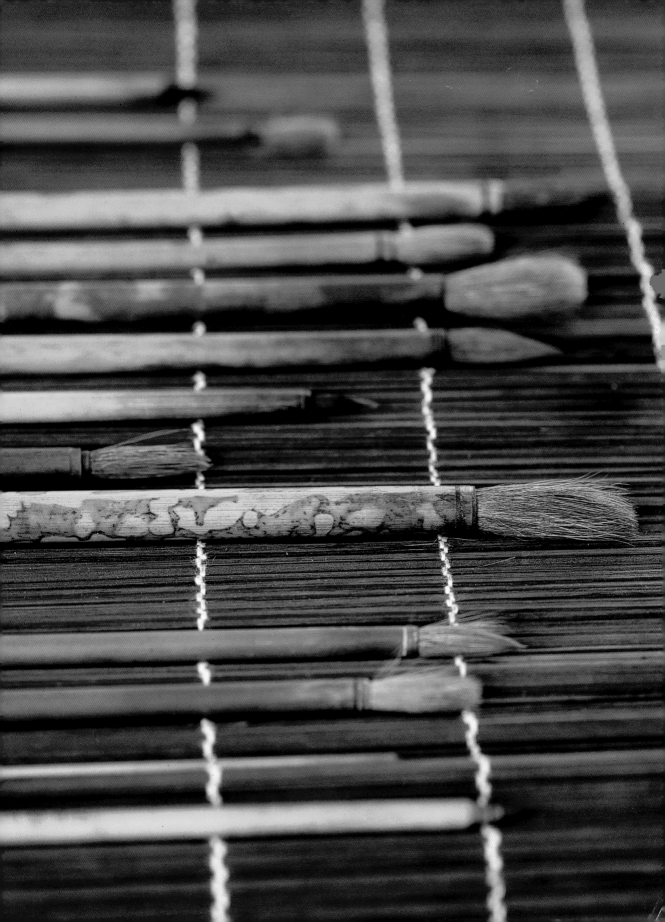

1 Preparing the Brushes

The tip of a new brush is held together with gum for presentation purposes and is usually protected with a bamboo or plastic cover. The gum has to be removed to free the hair for writing or painting. This process is called "opening the brush."

The technique used to open a brush for use in calligraphy is different from that used in painting. In painting, a whole brush tip is used, so it needs to be opened completely, with all the gum being removed. In calligraphy, it is difficult to control a fully opened new brush for writing, so it is only half-opened.

To do this, soak the brush tip in cold water for about 3–5 minutes. When the tip end starts to loosen, take it out of the water. Do not wait for the rest of the brush tip to loosen up. The process of using it for writing will eventually loosen the hair—and by then, the hair will have been seasoned and toughened through use. After soaking the brush tip, wipe it dry with tissue or a soft towel; the brush is now ready for use.

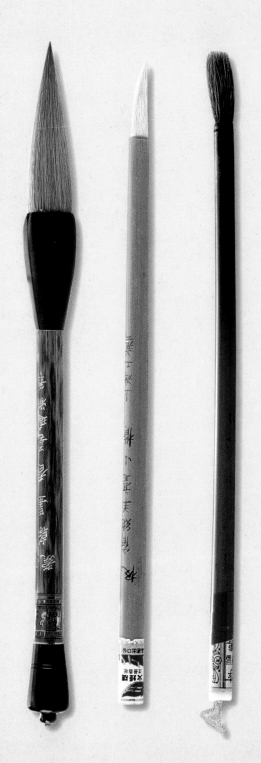

A gummed brush (left), a half-opened brush (middle) and a fully-opened brush (right).

Taking care of your brushes

A good brush is carefully crafted and deserves to be cared for properly. There are several things you can do to keep your brush in good condition and to prolong its life.

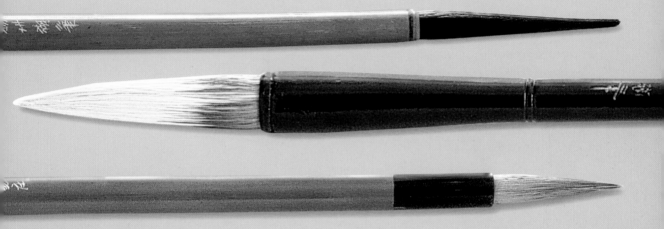

- Do not put your brush back into its cover once it has been opened, as the tip will be too big.

- Each time you use a brush, clean it under a cold tap with gently running water, or rinse it in a jar of water to get rid of as much ink as possible, then wipe it dry. Do not rinse the brush under a fast-running tap or with hot water, as this will harm it.

- Do not soak the brush unnecessarily in water.

- Never clean your Chinese brushes with washing liquid or soap; these form a film that sticks in the hairs and takes a long time to get rid of.

- After cleaning, mold the tip back to a point and leave it to dry.

- Wrap brushes in a brush mat for storage. This is made out of bamboo, and the gaps between the slats of the mat allow the brushes to breathe and dry.

- I keep my brushes perfectly in place on the mat using elastic loops. Cut a length of dressmaking elastic that equals the width of the mat. Thread it through the slats of the mat and secure the two ends of the elastic with stitches. The loops formed by the elastic are perfect for holding brushes.

- Do not store wet brushes in airtight containers or plastic bags. Chinese brushes are made of natural materials and can rot. Always dry them completely before storing them.

LESSON 2 | Holding and Loading the Brush

In calligraphy, the brush is always held in a vertical position. Practice holding your brush firmly to ensure smooth delivery of brushstrokes.

Where to hold the brush

The length of a handle is carefully designed to be in proportion to the size of the brush tip and to suit the way the brush is used. In calligraphy, the position of the grip varies according to the size of the script to be written. For Small Script, hold your brush about 0.8–1.2 in (2–3 cm) above the brush tip. For Large Script, hold the brush in the middle of the handle. For Big Writing, hold the brush about 6 in (15 cm), or three-quarters of the length above the brush tip; this allows you freedom to swing the brush.

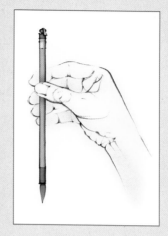

The simplest way of holding the brush is with the fingers on one side of the handle and the thumb on the other.

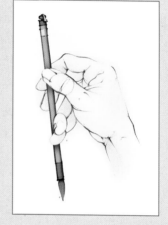

Another way to hold the brush is with two fingers on one side of the handle and with the other two fingers and the thumb on the other side. This provides added stability and firmness.

Different script sizes

Let's recap on the three common sizes of script used in Chinese calligraphy:

Small Script: individual words measure 1 x 1 in (2.5 x 2.5 cm) or less

Large Script: words of more than 1 x 1 in (2.5 x 2.5 cm)

Big Writing: words of usually more than 2 x 2 in (5 x 5 cm)

Where to rest your arm and wrist

For Small Script, hold the brush low down and rest your wrist on the table to steady it. If your wrist is too far from the surface, your brush may not reach the paper.

For Large Script, rest your arm on the surface but not your wrist. This is because you may have to use elbow movement, which will be restricted if your wrist rests on the surface.

For Big Writing, or with expressive styles such as the Tsao Shu, neither the arm nor wrist should touch the table. There should be no restriction to the movement. As a rule, your hand should never be higher than your shoulder because of the strain this will impose on your writing movement. For this reason, you should always stand up for these types of writing.

Loading the brush with ink

Pour out a small amount of ink at first, and allow it to thicken up for a few minutes before use (see page 22). Pouring a small amount avoids the problem of a large amount of ink thickening up too much. More ink can always be added when it is required.

You will only use the lower part of the brush tip for writing, so load only the lower half of the brush tip with ink. It is unneccesary to load too much ink. It will only make cleaning the brush more difficult.

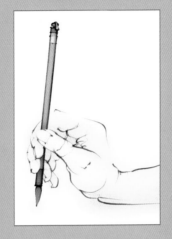

For Small Script, hold the brush 0.8–1.2 in (2–3 cm) above the brush tip. Rest your wrist on the surface.

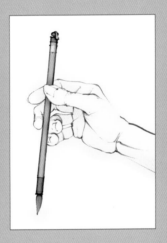

For Large Script, hold the brush in the middle of the handle. Rest your arm on the surface, but not your wrist.

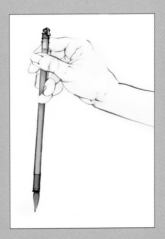

For Big Writing, hold the brush about 6 in (15 cm) above the brush tip. Your wrist and arm should not touch the table.

Three
Basic Techniques

Fluency and control are essential for creating beautiful Chinese calligraphy. The brush is effectively maneuvred using four different movements—which, when combined together, can be used to make a variety of shapes.

3 Wrist and Elbow Movements

Two different movements are used to control the direction of the paintbrush. Short movements are made using the wrist alone, while longer movements are made from the elbow.

Small brushstrokes

By rotating the wrist alone, we can make short movements with our hand, and therefore—with brushes—write short brushstrokes. Wrist movements are essential for writing Small Script and for the short brushstrokes needed in Large Script and Big Writing.

Practicing the wrist movement

Hold the small brush (see pages 28–29) 0.8–1.2 in (2–3 cm) from the brush tip. Rest your wrist and arm on your writing surface. Load the lower half of your brush with ink. Write the words to the right, the Chinese characters for the numbers 1, 2, 3, 4, 5, 6, 7, 8, 9, and 10. Do not worry about the order of the brushstrokes for the time being. The aim of this exercise is to get you used to moving the wrist.

After practicing a few times, lift your wrist away from the surface, but leave your arm still resting. Hold the brush in the middle of the handle and repeat the words using the wrist movement.

Large brushstrokes

The wrist movement alone is not sufficient for the long brushstrokes needed when writing Large Script and Big Writing. For longer brushstrokes, rotate the arm from the elbow; this will allow you to reach wider areas. Practice moving up and down by manoeuvering the elbow. Then move sideways left and right by rotating the elbow, as shown in the diagram to the right.

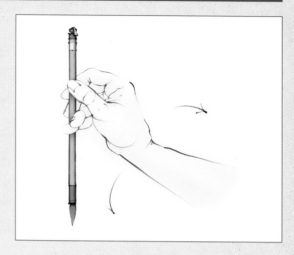

For small brushstrokes, control the brush using only the wrist, not the elbow or forearm.

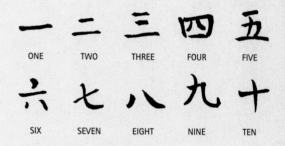

一	二	三	四	五
ONE	TWO	THREE	FOUR	FIVE
六	七	八	九	十
SIX	SEVEN	EIGHT	NINE	TEN

Practice writing the numbers one to ten to get used to controlling the brush from the wrist.

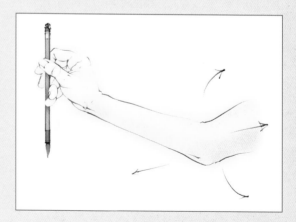

Large brushstrokes are controlled from the elbow.

Practicing the elbow movement

Hold a large brush in the middle of the handle. Rest your arm on your writing surface, but lift your wrist away from it. Load the lower half of your brush tip with ink. Practice the vertical, horizontal, and diagonal movements, shown here to the right.

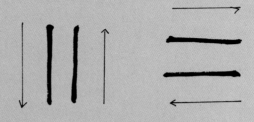

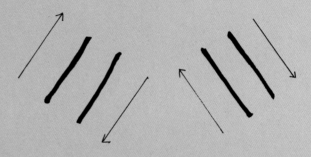

Combining the two movements

Most of the time, you will have to use both the wrist movement and the elbow movement when writing a single brushstroke. These final exercises, shown to the right, show you how to combine two brushstrokes to make a single, angled mark. Hold a large brush in the middle of the handle and practice changing direction and movement, as indicated by the arrows.

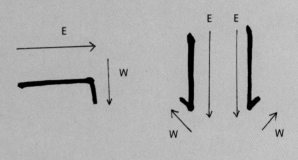

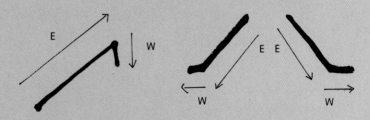

LESSON 4 Pressing and Lifting the Brush

Raising and lowering the brush as you write allows you to change the thickness of the brushstroke. By pressing the brush onto the paper, the hairs spread out and the mark becomes wider. By slowly lifting the brush, the tip returns to a point, making the shape thinner.

Practicing press and lift movements

Hold a large brush in the middle of the handle. Load the lower half of the tip with ink. Lift your wrist away from your writing surface, but rest your arm on it. Using the wrist movement, press the brush on the paper then lift it as you move it left to right. Do not rush; the movement should be gradual. The shape you create should look like the one illustrated in A. If you rush the movement, it is likely that your shape will not end with a point, as illustrated in B.

Repeat this press and lift in different directions, as illustrated in C.

Changing direction as you press and lift

Refer to illustration D. Use the press and lift movements to change the thickness of the mark, while simultaneously using wrist movements to change the direction in which the brush is moving.

Press and lift with elbow movements

For longer brushstrokes you need to move the arm from the elbow (as described on page 32-33) at the same time as lifting and pressing down the brush to taper the brushstroke. To practice this, prepare your brush and your arm and your wrist as before. Now press and lift the brush using the elbow movements to draw the brushstroke illustrated in E. Again, do not rush—the brush needs to be raised and lowered slowly to get the right shape.

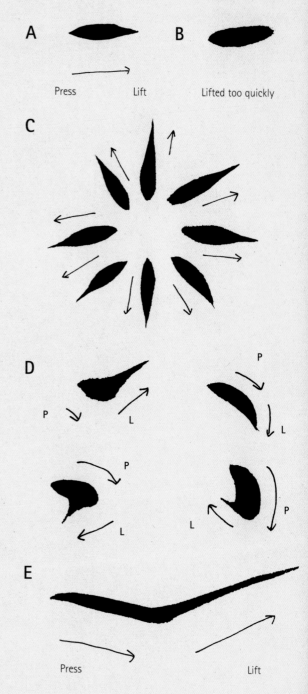

A B

Press Lift Lifted too quickly

C

D

E

Press Lift

Combining wrist and elbow movements with press and lift brushstrokes

With many brushstrokes, you will need to learn to combine all four of the movements you have learned— the wrist and elbow motions and the lift and press movements. Use the following exercises for practice:

P = Press W = Wrist
L = Lift E = Elbow

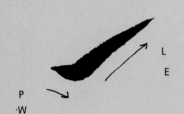

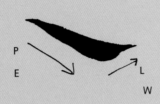

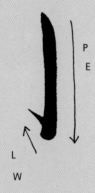

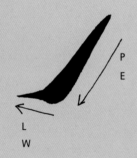

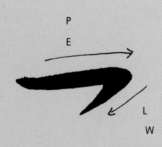

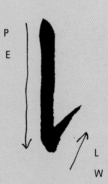

The next exercise is designed to let you practice a more complicated brushstroke. The more you practice, the more fluent you will become with all the movements.

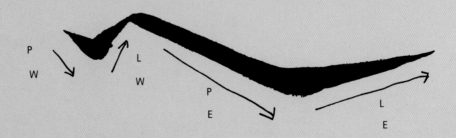

Basic Brushstrokes

Every Chinese word is a unique composition, essentially constructed using just eight basic brushstrokes, shown opposite. Sometimes, however, variations are required to maintain the overall balance of a composition.

In these next lessons, we are going to learn and practice the eight basic brushstrokes and their common variants. Use the short tip, goat-hair Small Script brush. Hold it in the middle of the handle, and rest your arm so that your wrist is off the paper. Load the lower half of the brush tip with ink. Start with the small brush, and when you are confident try a larger brush.

Horizontal brushstroke

Vertical brushstroke

Dot

Hook

Press and lift upward

Press and lift downward

Diagonal brushstroke
to the left

Diagonal brushstroke
to the right

5 Horizontal Brushstrokes

By practicing the horizontal brushstroke as often as possible, you will improve your technique and strengthen your brush movements. Horizontal brushstrokes (and the vertical ones we will cover in the next lesson) are the backbones of Chinese words. When writing a horizontal brushstroke, I look for a proper beginning, a smooth and uniform movement across, and a proper ending.

Anatomy of a horizontal brushstroke

The process of writing a horizontal brushstroke can be broken down into six steps.

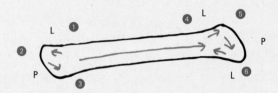

Remember that all steps are connected in a continuous movement; your brush should not leave the paper between steps.

Six steps to a horizontal brushstroke

1. Move the tip of the brush with the wrist, following the arrows shown in the diagram.

2. Use the wrist movement to press the brush downward. Don't press too hard, or the brushstroke will have a big head.

3. Lift the brush very slightly and move to the right using the elbow movement. This step forms the main body of the brushstroke.

4. Lift the brush and move slightly upward to the right.

5. Press the brush down, using the wrist movement.

6. Lift the brush and move according to the direction indicated back into the body of the brushstroke.

Repeat the six steps in one continuous process.

Types of horizontal brushstroke

Long form

A long horizontal brushstroke becomes the focus of a Chinese character. Use the elbow movement to ensure a smooth motion across the surface.

Short form

Use the wrist movement.

Short, pointed form

This is written by skipping Step 1 (see above), resulting in a pointed beginning.

Angled form

In some Chinese words, a usual flat horizontal brushstroke can be written in an angled form to add beauty to the overall structure.

Forming words

Once you've got the hang of horizontal brushstrokes, you can start to form words. The diagrams in the left-hand column below show you the outline of such words, and the numbers indicate the order of writing the brushstrokes. Let's paint the words for the numbers one to three, forming each of the horizontal lines in the correct way, using the the six-step movement you have just learned.

Ensure that when forming the brushstrokes, you keep an eye on the distances between them.

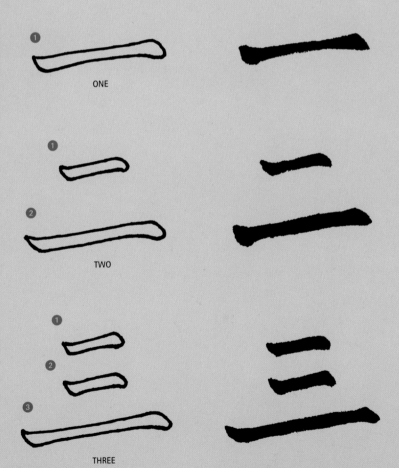

ONE

TWO

THREE

Problem solver

Big head
You pressed too hard at Step 2. Remember the movement is subtle.

Shaky body
In Step 3, you used the wrist movement instead of moving the arm from the elbow.

Untidy ending
The last step is too hasty. Always aim to go back toward the body of the brushstroke at Step 6.

Too much ink
Squeeze out excess ink on the side of the ink reservoir when you load your brush. Don't hesitate in your movement. Staying too long at any one spot results in overinking.

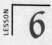 LESSON 6 Vertical Brushstrokes

The qualities looked for in a vertical brushstroke are similar to those needed for a horizontal brushstroke; you need a proper beginning, a straight, uniform main body, and a proper ending. The elegance of a Chinese word will depend on the quality of its vertical brushstroke.

Anatomy of a vertical brushstroke

The process of writing a vertical brushstroke can be broken down into five individual steps.

Remember that all the steps are connected as a continuous process; your brush should not leave the paper between steps.

Five steps to a vertical brushstroke

 1. Use the tip of the brush, move up as indicated by the arrow, and make a small brushmark.

 2. Press down slightly.

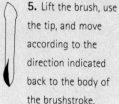 **3.** Use the elbow movement and move down the paper with uniform width.

 4. Very slightly press to the left. (Pressing too much will cause an unattractive blob at the bottom of the brushstroke.)
Now repeat the five steps in a continuous process.

 5. Lift the brush, use the tip, and move according to the direction indicated back to the body of the brushstroke.

Types of vertical brushstroke

 ### Long form
A long vertical brushstroke is the focus of a Chinese word. Use the elbow movement to make sure that it is straight and uniform in width.

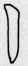 ### Short form
Use the wrist movement.

Pointed form
Use Steps 1 to 3, but, as you paint Step 3, gradually lift the brush to end with a point. The pointed form is used when the vertical brushstroke runs right through the word from top to bottom—with nothing attached to the top or bottom. The character 十 for the word "ten," in this lesson, and 中 for the word "middle" (tackled in the next lesson) are examples.

When a vertical brushstroke has no attachment to the bottom but has other marks on top of it, like the word 早 (see page 45), the long or short form is used depending on the size of the word.

Forming words

To form words, you must learn to combine brushstrokes. The following are examples of combining horizontal with vertical brushstrokes. Each is given with its outline, its meaning, and with a guide to the order in which the individual brushstrokes should be written. When a vertical brushstroke meets another brushstroke at its bottom end, skip the last two steps. When it attaches to another at the upper end, leave out Step 1. For example, in the character for the word "correct" (see below), the fourth brushstroke stops at Step 3, and the second brushstroke misses Steps 1, 4, and 5.

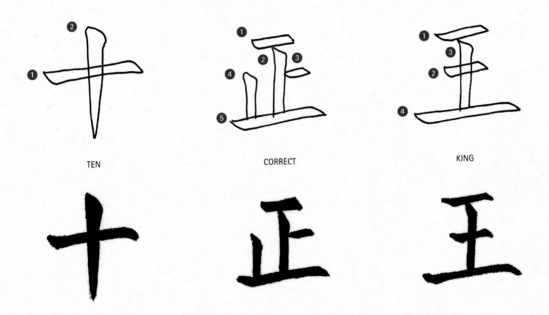

TEN CORRECT KING

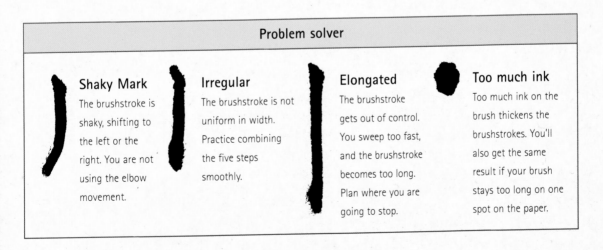

Problem solver

Shaky Mark
The brushstroke is shaky, shifting to the left or the right. You are not using the elbow movement.

Irregular
The brushstroke is not uniform in width. Practice combining the five steps smoothly.

Elongated
The brushstroke gets out of control. You sweep too fast, and the brushstroke becomes too long. Plan where you are going to stop.

Too much ink
Too much ink on the brush thickens the brushstrokes. You'll also get the same result if your brush stays too long on one spot on the paper.

7 Combining Horizontal and Vertical Brushstrokes

Most combinations of horizontal and vertical brushstrokes are straightforward. One brushstroke is written after another, with the last two steps of the first merging with the first two steps of the second. Figures A and B are examples of this (see below). Occasionally, a smoother transition from one brushstroke to another is used – providing a rounded corner. This is when the final steps of the first brushstroke and the initial steps of the second brushstroke disappear entirely and the combination becomes one continuous brushstroke. Figures C and D are examples of this.

A

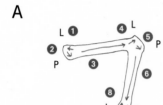

Steps 4 (lift) and 5 (press) of a horizontal brushstroke (see page 38) become Steps 1 (lift) and 2 (press) of the vertical brushstroke (see page 40). These lifting and pressing steps are important for turning corners. Lifting the brush allows it to be adjusted for the change of direction. The brush is then pressed down and moved to form the body of the second brushstroke.

B

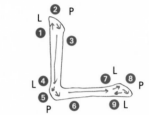

Steps 4 and 5 of the vertical brushstroke become Steps 1 and 2 of the horizontal brushstroke.

C

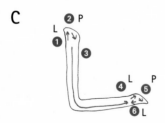

The last two steps of the vertical brushstroke and the first two steps of the horizontal brushstroke are left out. One continuous brushstroke replaces them, making the corner rounder and smoother.

D

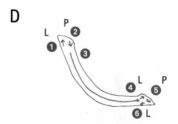

The vertical brushstroke and the horizontal brushstroke have merged into one smooth brushstroke in an angled form.

Forming words

Here are examples that use combination brushstrokes. Each is given with its outline, its meaning, and with a guide to the order in which the individual brushstrokes should be written. Note that horizontal and vertical brushstrokes do not necessarily have the same width when used in a single word; usually, the horizontal ones are thinner.

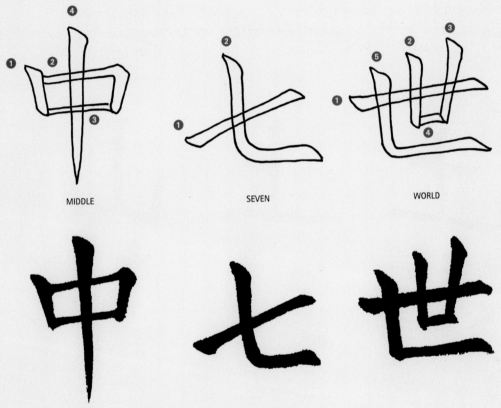

MIDDLE SEVEN WORLD

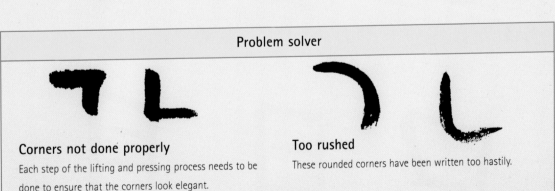

Problem solver

Corners not done properly

Each step of the lifting and pressing process needs to be done to ensure that the corners look elegant.

Too rushed

These rounded corners have been written too hastily.

More Chinese Words to Try

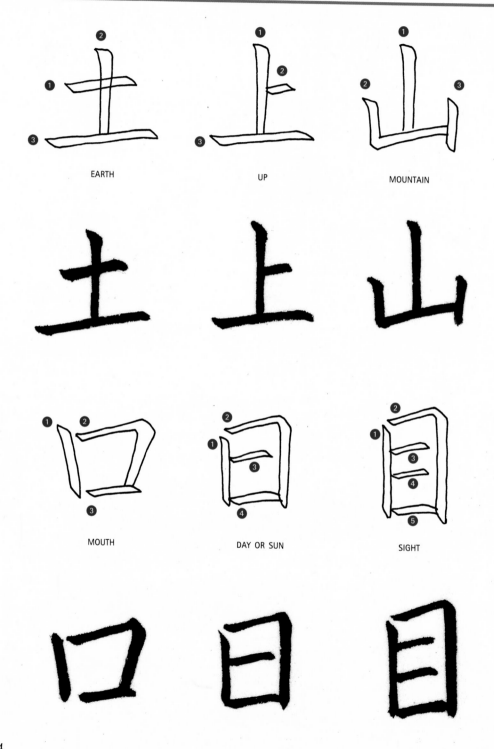

EARTH

UP

MOUNTAIN

MOUTH

DAY OR SUN

SIGHT

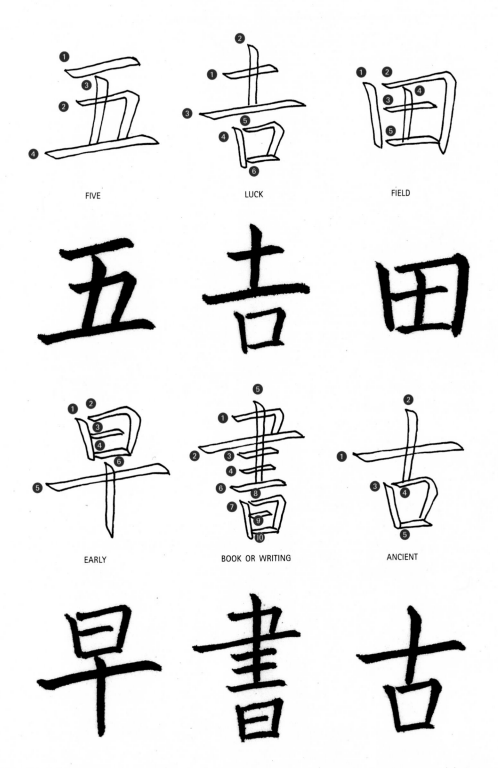

FIVE　　　　　　　　　LUCK　　　　　　　　　FIELD

EARLY　　　　　BOOK OR WRITING　　　　　ANCIENT

1 Writing the Word for "Luck"

The word 吉, meaning "luck," is frequently used by Chinese people. It is written on posters, cards, wrapping paper, and many other types of decoration in the hope that it will bring good fortune. Even clothing, shoes, handkerchiefs, and bags often have 吉 embroidered on them. A popular way of using this word is to write it in gold paint on a big piece of diamond-shaped red paper. It is also a good word for practicing what you have learned so far.

When I was young, my father and I would write the word "luck" a lot, usually during the week before Chinese New Year, when old wall writings had to be removed and fresh ones put up. As head of the family, my father would write them in gold paint. As a child, I would write them in ink.

In this project, we are going to make a eraser stamp for the 吉 word. Then you will be able to write the word in small sizes on thin calligraphy paper and stick it onto cards to send to your friends.

Cutting a eraser stamp

The Chinese use a similar method to the one used here to craft their seals. I have modified the technique to cut a piece of eraser to make a relief printing block.

You will need:

- Eraser
- Piece of Xuan paper, slightly larger than the shape of the eraser
- Ink or colored paint
- Small brush
- Craft knife

1. Cut a piece of eraser to the size you prefer; a pencil eraser is ideal. Cut a sheet of Xuan paper so that it is slightly bigger than the eraser. Place the eraser in the center of the paper, and trace its outline.

2. Write the word 吉 on the paper inside the shape using ink.

3. Before the ink dries, press the eraser down onto the paper, matching the marked shape with that of the eraser. Push down firmly.

4. The ink will leave a negative image of the word on the eraser. With a sharp craft knife, cut away all the surface of the eraser that is not covered in ink, to the depth of around ⅛ in (3 mm).

5. Now you have the finished stamp, with the word written in reverse.

6. Brush the shape with ink or colored paint. Stamp it on a piece of paper, pressing down firmly. Slowly remove the eraser. The finished artwork appears on the paper the right way round.

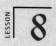

8 Dots

The dot is probably the oldest brushstroke in calligraphy. It began with a round dot in Chuan Shu and has developed over thousands of years into the many forms currently used. Let's start with the standard dots used today.

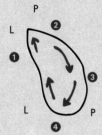

Anatomy of a right dot

The most common form of dot leans to the right and is therefore known as a "right dot." The construction of this dot can be broken down into four steps, as shown in this diagram.

Anatomy of a left dot

A dot leaning to the left is called a "left dot." This is again drawn in four steps, but the brush moves in a counterclockwise direction.

Four steps to a right dot

Every step is a small movement. Use wrist movements for all the steps.

 1. Start with the tip of the brush and move up, following the arrow shown in the diagram.

 2. Press the brush slightly downward to the right.

 3. Continue to press, but move the brush slightly to the left.

 4. Lift the brush and move upward, back into the body of the dot, to finish off.

 Repeat the four steps again in a continuous process. Your brush should not leave the paper between the steps.

Arranging dots

When a single dot is used, it is usually the right dot.

MASTER

When two dots are used in a word (in this case one on each side), a left dot is used on the left and a right dot on the right.

ALSO

Three dots are used in this word. When only right and left dots are used in a word, they are arranged left dot first, followed by two right dots.

SMALL

When four dots are used, they are arranged in one of two ways:

left left right right

left right right right

BLACK

Forming words

The following are some of the Chinese words formed by using only dots, horizontal brushstrokes, and vertical brushstrokes. The order in which each brushstroke is made is indicated.

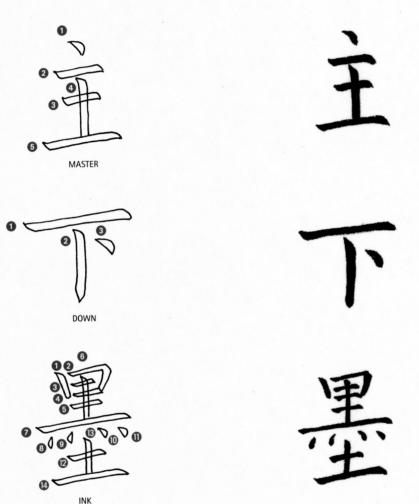

MASTER

DOWN

INK

Problem solver	
Incomplete The last step for constructing the dot is missing.	**Written in haste** These have been written without following all the steps.

9 More Dots

Dots have many more shapes than the simple right and left forms. These variations add a dramatic quality to composition. When using Hsing Shu, these variations often replace standard dots, helping to make it much freer script. The most common variations are shown below.

Anatomy of dots in different shapes

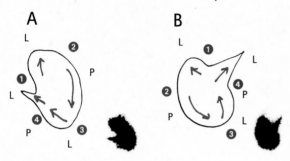
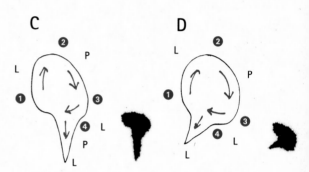

The secret of writing these pointed dots lies in the last two steps. At the end of Step 3, lift the brush as you move it toward the center of the dot, press slightly, and then gradually lift to achieve the point. This lifting and pressing process allows you to adjust the direction that the brush is moving in before the final lifting.

Hsing Shu uses these dots liberally in forming words. You will find that even with a particular word, different dots may be used on different occasions to suit the overall presentation of the writing. The more common uses for the four different forms shown above (A, B, C, and D) are explained below.

Variations

MASTER	TOGETHER	FRUIT	SMALL	STREAM	BLACK

MASTER
A single dot is usually written using form A. This is an another way to write the word "master" learned earlier (see page 49).

TOGETHER
When two dots are used, shapes B and D are the most popular.

FRUIT
In Hsing Shu script, the A and B forms often replace the two long brushstrokes on each side of 木, which forms the lower part of a word like the one here.

SMALL
When three dots are used, as in this word learned earlier (see page 48), they can be written using the B, B, and D forms, in that order.

STREAM
Any word having ⌣ on the left side will use the three dots D, C, B, written in this order and arranged to form a curve.

BLACK
When four dots are used, the word can be written with B, B, B, D, in this order ⌣ ⌣ ⌣ ⊳. Very often in Hsing Shu, it is written in a more expressive style ⌣, beginning with B and ending with D.

Forming words

In Hsing Shu, dots are positioned so that there is a line of movement running through them. Take the three words on this page, for example. The lines of movement for each are illustrated with red arrows. To achieve beautiful calligraphy, practice writing groups of dots along the imaginary lines of movements.

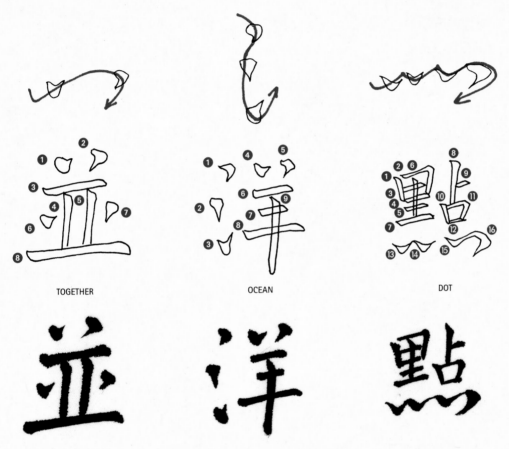

TOGETHER

OCEAN

DOT

Problem solver

Incorrect ending
The last step has been rushed.

No fluidity in composition
There are no imaginary lines of movement in these groups of dots.

2 Making a Traditional Writing Book

In ancient times, writing was done in books folded concertina fashion, as well as on scrolls. In this project, I will show you how to make a book like this. I have written the words 書墨 on the front cover, which means "writings in ink"—these words were learned on Sheet 1 (see page 45) and in Lesson 8 (see page 49) . You could use this book to record all the new Chinese words that you learn.

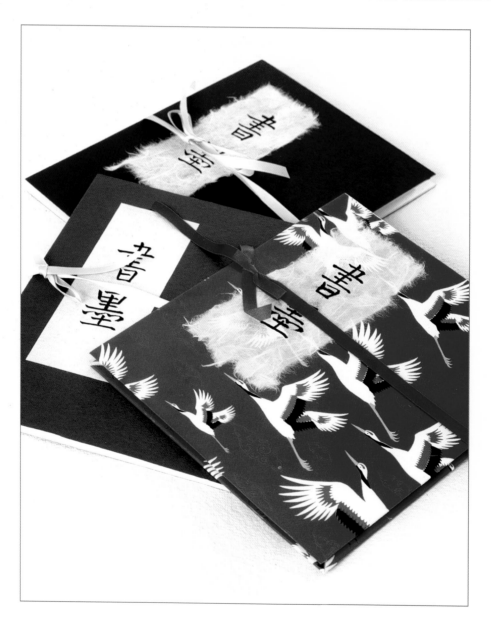

You will need:

- Sheet of paper 59 in (150 cm) long cut from a roll of "Moon Palace" 15 inches wide. (This paper is traditionally measured in inches.) If you do not have "Moon Palace," you can cut a piece of Xuan paper 59 x 15 in (150 x 38 cm); if necessary, you can paste two pieces together.
- Two pieces of thick cardboard, each measuring 8.3 x 7.5 in (21 x 19 cm)
- Length of thin ribbon 27.6 in (70 cm) long
- Sheet of Xuan paper measuring 5.5 x 2.4 in (14 x 6 cm)
- Thin piece of card measuring 5.9 in x 5.1 in (15 x 13 cm)
- Glue
- Pencil
- Ruler
- Craft knife
- Brush
- Ink

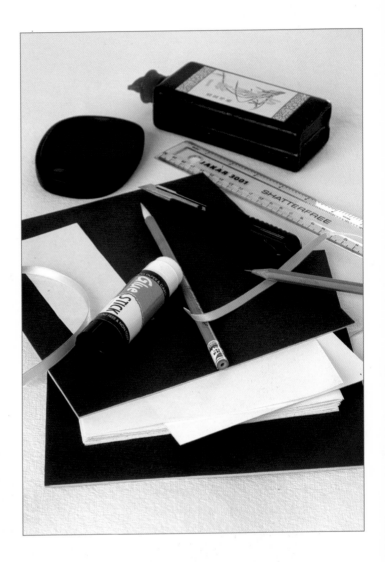

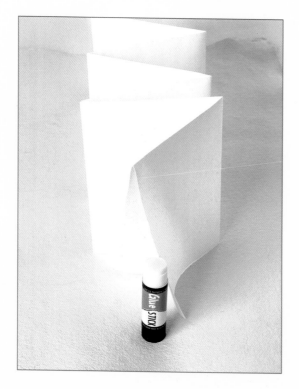

1. Fold the 59 in (150 cm) paper in half lengthwise. If you are using "Moon Palace" paper, keep the smooth surface on the outside. Measure 5.9 in (15 cm) intervals along the folded paper, and mark them lightly with a pencil. Fold the paper concertina-style along the pencil marks to form the pages of the writing book. Take the page at one end of the book. Apply a little glue on the inside of the folded paper, and press it together. Repeat with the page at the other end. When the glue is completely dry, fold it up into a book shape ready for the next step.

2. Apply glue thinly to the top of the book, then press the back of one of the pieces of thick cardboard onto the sticky page. Make sure that the book is attached to the center of the card. Press firmly. Turn upside down, and apply glue thinly to the top of the book. Press the back of the other piece of thick cardboard on top, again making sure that the book is in the center of the card.

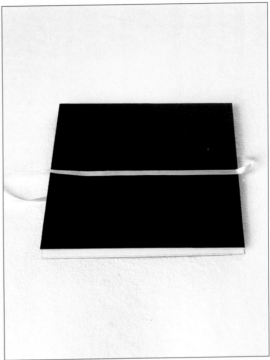

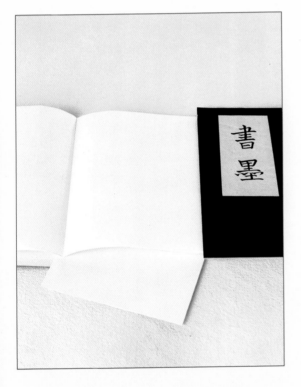

4. Lay the ribbon on a flat surface. Mark the middle of the ribbon. Place the book, with the back cover upward, onto the ribbon as shown in the photograph. Fold the ribbon over, so that the middle mark lines up with the "spine" of the book. Attach the length of ribbon in contact with the back of the book with a bit of glue. When the glue is completely dry, tie the ribbon in a bow.

3. Write the words 書 墨 in ink on the Xuan paper using the paintbrush. Attach it to the front cover with a little glue. The photograph above shows the finished front cover of the book—notice that the Chinese open books the opposite way to Westerners. Place the piece of thin card inside a page. When you write in ink, this thin card will prevent ink from seeping through to the other pages. Make sure you insert it behind whichever page you are writing on.

10 Hooks

Hooks are extensions to the horizontal and vertical brushstrokes, designed to add beauty to the composition. The common mistake in constructing hooks is to rush them. Most people believe that you have to lift very fast to form the hook; in fact, the secret to an elegant hook is to lift the brush gradually.

Anatomy of a hook to a vertical brushstroke

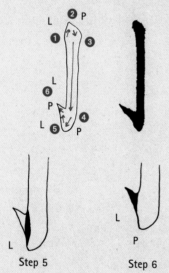

Step 5 **Step 6**

The first four steps are the same as those used to form a normal vertical brushstroke (see page 40). However, two last steps (see above) are vital to writing a beautiful hook. In Step 5, lift the brush to allow for the change of direction. In Step 6, press slightly and lift in the direction of the hook. Do not rush this process. This pressing and lifting action will produce an elegant finish.

Anatomy of a short hook to a horizontal brushstroke

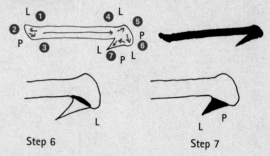

Step 6 **Step 7**

The first five steps are the same as a horizontal brushstroke (see page 38). Step 6 and Step 7 finish the extension with a hook.

Anatomy of a long hook to a horizontal brushstroke

Some hooks extended from a horizontal brushstroke are drawn longer than others. These are a combination of a horizontal brushstroke with the press and lift downward brushstroke, which you will learn about in Lesson 13.

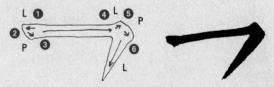

Other variations

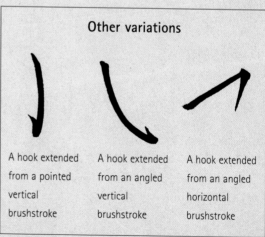

A hook extended from a pointed vertical brushstroke

A hook extended from an angled vertical brushstroke

A hook extended from an angled horizontal brushstroke

Forming words

Here are some words that use a variety of hooks, in conjunction with more flamboyant forms of dots.

SMALL

RICH

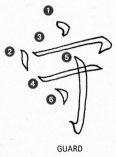

GUARD

Problem solver

Acceptable, but not elegant
These hooks miss the penultimate step.

Too hasty
These hooks have been written in a rush.

11 More Hooks

In Lesson 7, we looked at the different ways in which horizontal and vertical brushstrokes can be joined together (see page 42). If we extend these combination brushstrokes with hooks, we can create a variety of striking shapes.

Anatomy of hooks added to combined horizontal and vertical brushstrokes

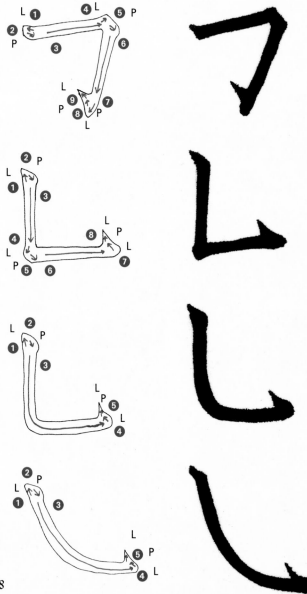

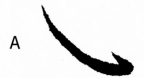

Other variations

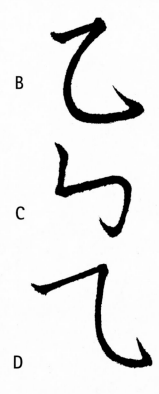

Hook A extends from a pointed vertical brushstroke in angled form. Refer to the word "Heart" on the opposite page.

B, C, and D are curved brushstrokes with hooks. Their beginnings, corner turnings, and hooks are similar to the illustrations on the left. Examples of words using these brushstrokes are "horse" (see page 60), "fly," "nine," and "wind" (see page 77).

Forming words

Below are three words with hooks combined to horizontal and vertical brushstrokes. There are more words like this for you to practice on pages 60-61.

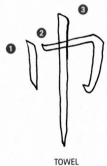

TOWEL

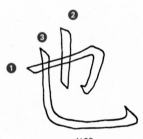

ALSO
(THIS WORD IS ALSO USED TO END A SENTENCE, INDICATING CERTAINTY)

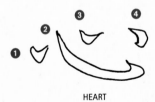

HEART

Problem solver	
No elbow movement	**Incomplete**
A wrist movement has been used to write the long part of each brushstroke, so it is curved rather than straight.	The hook does not end with a point. Rushing will be an ongoing problem if you do not learn to control.

2 More Chinese Words to Try

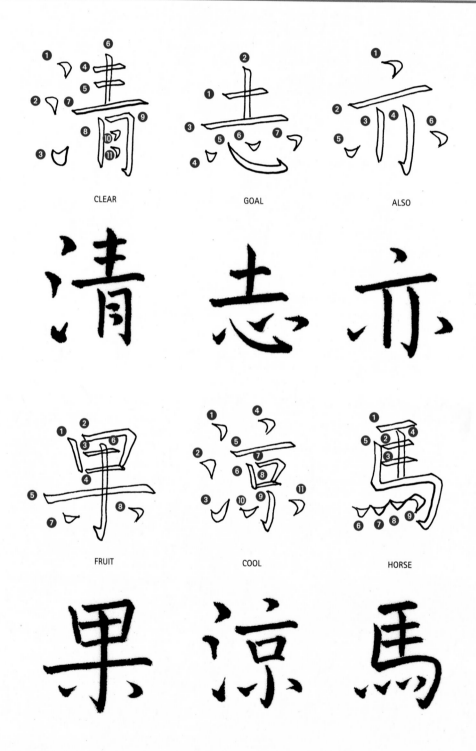

CLEAR　　　　GOAL　　　　ALSO

FRUIT　　　　COOL　　　　HORSE

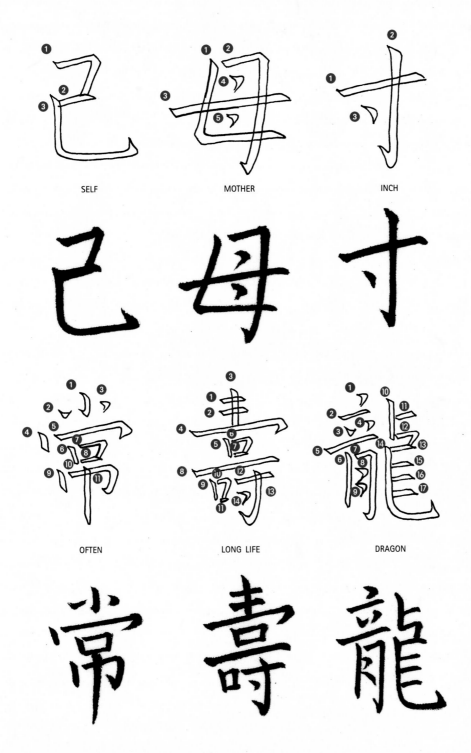

SELF

MOTHER

INCH

OFTEN

LONG LIFE

DRAGON

61

3 Writing the Word for "Long Life"

壽 means "long life." It is often written on its own to celebrate birthdays—particuarly important ones, such as a sixtieth or a hundredth. To the Chinese, reaching 60 years of age is a perfect cycle, as the calendar runs over a 60-year period. People who reach 60 are considered to have had a full life. The Chinese also believe 100 is a perfect number—and that a person who lives to the age of 100 is a special gift from heaven.

In this project, we will make a "long life" greeting. You can write 壽 in big or a small-sized script. A big one could be used as a centerpiece for a birthday party decoration, while a small one could be turned into a birthday card to send to a friend.

You will need:

- Piece of Xuan paper big enough on which to write the word 壽
- Piece of thin blank paper about the same size as the Xuan paper. Ordinary white writing paper will do perfectly.
- Piece of thin card coated with metallic color on one side. The size of the card must be bigger than the sheet of Xuan paper that you use. If you can't find thin metallic card, you can use ordinary thin card or craft paper with a thickness of about 230 gsm.
- Brush and ink for writing
- Pencil for tracing and rubbing
- Flat board or a piece of thick cardboard to work on
- Two pieces of paper towel
- Masking tape

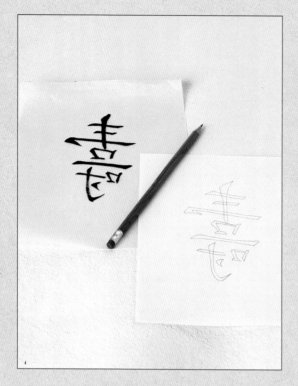

1. Load a brush with ink and write the word on the Xuan paper. (The order of the brushstrokes is given on page 61.)

2. When the ink is dry, turn the paper upside down. Place the writing paper on top of the word, and trace the outline of the reverse image of the word (see above).

3. Place the board on a flat surface. Put the two pieces of paper towel on the board to act as a cushion, and place the thin card, metallic side down, on top of the towels. Position the writing paper in the center of the reverse side of the thin card, and secure in position using masking tape (see above).

4. Use a pencil to rub over the area enclosed by the outline of the word. You will need to rub very hard. When you finish rubbing the whole area, remove the masking tape and the writing paper. An image of the word will stand out on the metallic side of the thin card.

Cut-out in expressive style

You can also make a three-dimensional effect by cutting out the characters from card or colored paper. Here I wrote out the character for "long life" on Xuan paper using a more expressive script. I then laid this on top of a sheet of red paper and cut around the outline of the word.

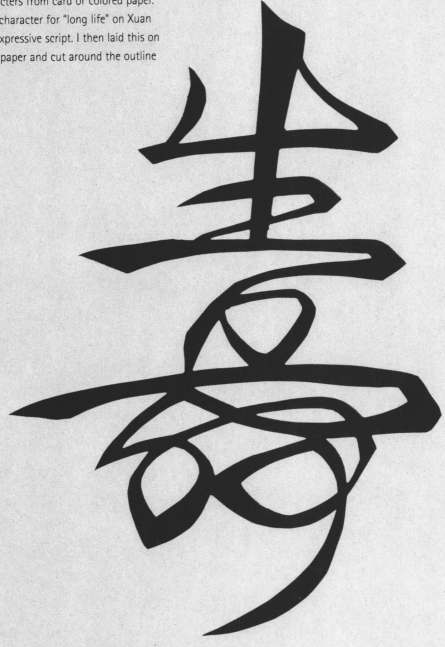

12 Press and Lift Upward

The brushstrokes in Lessons 12 and 13 look like elongated dots, but there are many differences. Dots use wrist movements, while these brushstrokes use elbow movements for the last step. Dots use lifting in Step 3 to produce shorter and more lively points. To construct the brushstrokes in these next two lessons, the pressing in Step 2 becomes the beginning of the gradual lifting in Step 3, resulting in longer and more solid points.

Anatomy of a press and lift upward brushstroke

The process of writing a press and lift upward brushstroke can be broken down into three steps. Remember, as usual, all steps are continuous – your brush should not leave the paper between the steps.

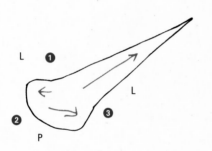

Three steps to a press and lift upward brushstroke

 1. Using the wrist movement, make a small movement in the direction shown.

 2. Press down with the wrist movement. Do not press too hard, or the left side of the brushstroke will be too large.

 3. Using the elbow movement, gradually lift the brush while writing in the direction shown. Do not rush the lift, or it will be too short and the brushstroke will look like a dot.

 Repeat the three steps as a continuous movement.

Variations of this brushstroke

Long angled form **Short angled form**

Horizontal form **Vertical form**

The angled form is the most commonly used version of this brushstroke. It can be used long, like the third brushstroke of 打 on the next page, or it can be used short, like the third brushstroke of 地 on the next page.

Horizontal: Refer to the first brushstroke of 子 in Lesson 13. Vertical: Refer to the word 计 on the next page. Compare the three dots with those in Lesson 9. The third dot of 氵 in this word becomes a press and lift upward brushstroke. Another example is the word 红, on page 71, where the three dots are replaced by a press and lift upward brushstroke. All these words having different forms illustrate the flexibility of using brushstrokes in Hsing Shu.

Forming words

The press and lift upward brushstroke is used in many different forms and lengths. The following words shown give a limited idea of the variety possible. More examples are given on pages 70-71.

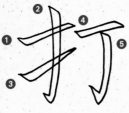

HIT

JUICE

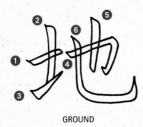

GROUND

Problem solver

Left side is too large

The brush has been pressed own too hard in Step 2.

Too much like a dot

Give Step 3 more time. Do not rush it. This looks more like a dot than a press and lift upward brushstroke.

Brush lifted too quickly

The lifting must be gradual in Step 3.

13 Press and Lift Downward

The procedures for writing this brushstroke are very similar to those learned in Lesson 12. As with the press and lift upward brushstroke, the downward version relies on an elbow movement being used for its third and final step.

Anatomy of a press and lift downward brushstroke

The process of writing a press and lift downward brushstroke can be broken down into three steps.

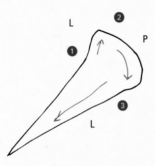

All steps must be connected into a fluid, continuous movement. The brush must not leave the paper in between steps.

Three steps to a press and lift downward brushstroke

1. Use the wrist movement and make a small move indicated by the arrow in the diagram to the left.

2. Press down with the wrist movement. Do not press too hard, or the right side of the brushstroke will be too large.

3. Press and lift with the elbow movement in the direction indicated. Lift gradually. Do not rush the lift, or it will be too short and the brushstroke will look like a dot.

Repeat the three steps in a fluid, continuous movement.

Types of press and lift downward brushstroke

Long angled form Short angled form

These two angled forms are the most commonly used. When a word has two angled forms of this brushstroke, one is written shorter than the other. One example is the word 竹 in Sheet 3 (see page 71).

Horizontal form

This brushstroke is equivalent to the horizontal form of the diagonal brushstroke to the left in Lesson 15 (see pages 78–79).

Vertical form

The brushstroke can be long, like the one used in the word 萬 in Sheet 3 (see page 71) or it can be short, like the one used in the word 紅 (see page 71).

Forming words

The press and lift downward brushstroke is used more often than the press and lift upward brushstroke. Sometimes it is used to replace the diagonal brushstroke to the left (see Lesson 15, pages 78-79). The following three words illustrate its usage; there are more examples to practice in Sheet 3 (see pages 70-71).

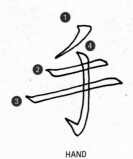

HAND

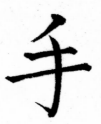

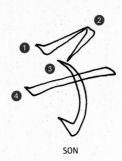

SON

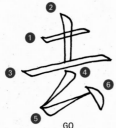

GO

Problem solver

Right side is too large
You pressed too hard in Step 2.

Too rushed
Take more time over Step 3.

Brush raised too quickly
The lifting was not gradual enough.

3 More Chinese Words to Try

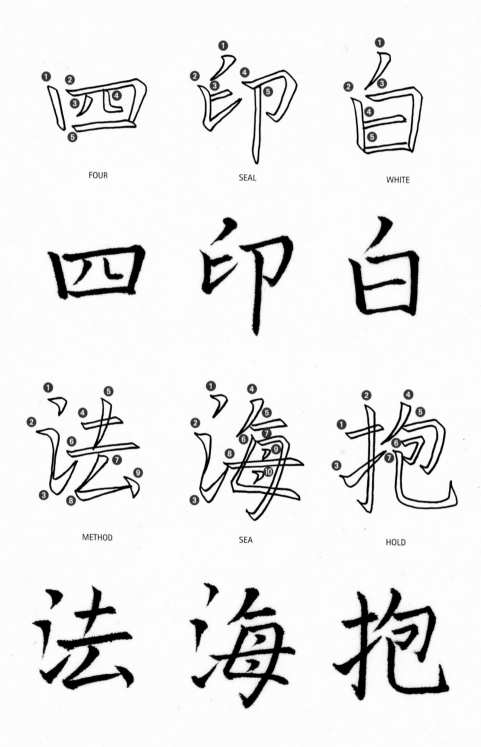

FOUR

SEAL

WHITE

METHOD

SEA

HOLD

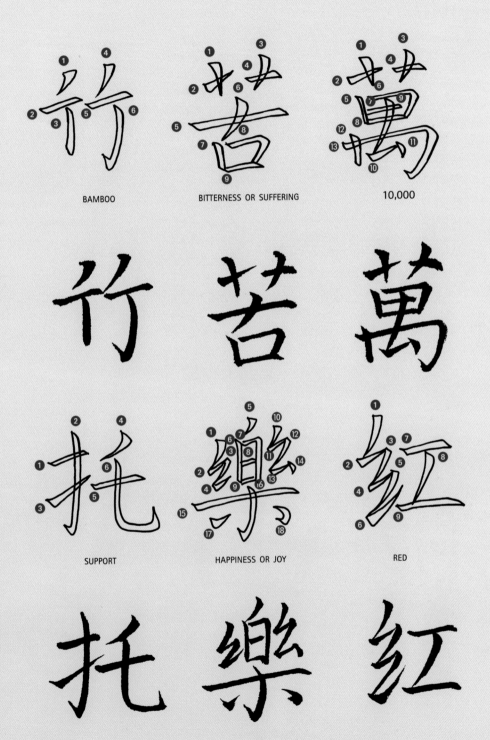

BAMBOO

BITTERNESS OR SUFFERING

10,000

SUPPORT

HAPPINESS OR JOY

RED

PROJECT 4 Writing the Words for "Happiness in Suffering"

You have now learned the proper way to write nearly all the key brushstrokes in Chinese calligraphy. Before we progress to the final few brushstrokes, let's bring together all you have learned so far by writing a well-known Chinese saying.

There are three words in this project. The first word means "bitterness" or "suffering." Refer to Sheet 3 for the instructions for writing this word (see page 71). The second word means "middle" or "in the middle of" (see page 43) and the third word means "happiness" or "joy" (see page 71).

When you put the three words together starting from right to left (the Chinese way of reading), the phrase literally means "happiness in suffering." It is a philosophical way of saying look on the bright side of life whenever you are having a bad time. The expression is a way to encourage yourself or a friend that there may be happiness hidden in what is happening. It is similar to the English proverb "every cloud has a silver lining" or to the idiom "a blessing in disguise."

These three words contain all the brushstrokes you have learned so far—horizontal and vertical brushstrokes, their combinations, the different shapes of dots, hooks, and press and lift brushstrokes, upward and downward. Have fun revising them!

You can write these three words in Small Script on a card to send to a friend who is feeling down. If you are full of confidence, why not try making a corner bookmark?

Before doing this, you should revise and practice the three words.

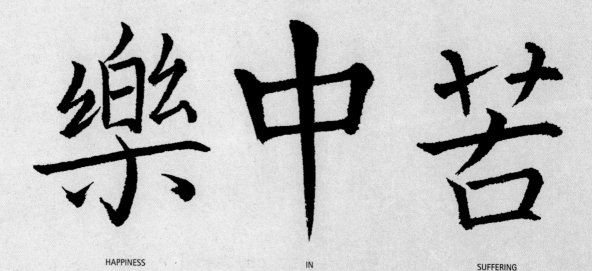

HAPPINESS IN SUFFERING

樂 中 苦

Making a corner bookmark
You will need:

- Colored envelope made of quality paper
- Short tip Small Script brush (wolf hair or goat hair)
- Ink
- Pencil and ruler
- Craft knife

1. Fold out the flap of the envelope. Draw a line across one of the envelope corners.

2. Use the brush and ink to write the three words.

3. Draw a decorative pattern around the three words, then cut out the unwanted area of paper with a craft knife.

4. Open your book and slip your new bookmark onto the corner of a page.

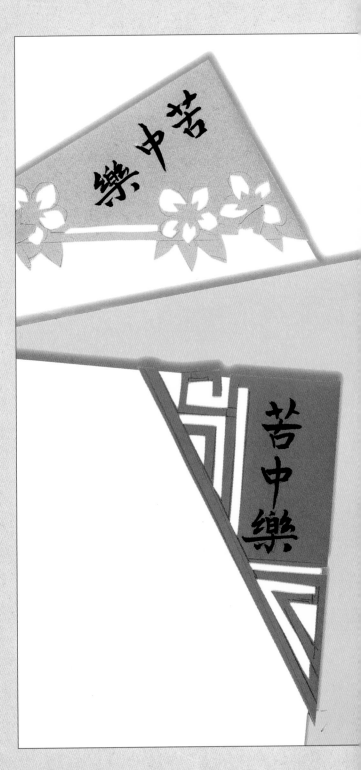

Big Writing on mulberry paper

Let's use Big Writing to write "Happiness in suffering" so that it can be hung on a wall, at home or the office, to cheer you up when things aren't quite right.

You will need:

- Long tip, goat-hair Large Script brush
- Chinese mulberry paper (This is different from the mulberry paper made in Western countries, which has a loose texture and is not very suitable for writing. Chinese mulberry paper has a tighter texture.) If this is not available, use a piece of Xuan paper.
- Blue watercolor paint and a big watercolor brush
- Ink
- Hand sprayer, filled with clean water

1. Dilute the blue watercolor in a wide container. Spray the paper with the clean water.

2. Use the big watercolor brush to apply the diluted blue watercolor to the wet Xuan paper. Apply it in any pattern you like. I like to let the color run as well as leaving some spaces untouched. Let dry.

3. Write the three characters on the paper using the ink. Pay special attention when writing the final, vertical brushstroke in the word "middle." Load the brush fully with ink. Write the brushstroke, and sweep it down with a steady elbow movement until the ink runs dry. You will probably have to practice this brushstroke a few times before your final attempt. Exaggerate some of the brushstrokes to add more movement to the artwork.

4. You can back the artwork on thicker paper following the instructions in Chapter 7.

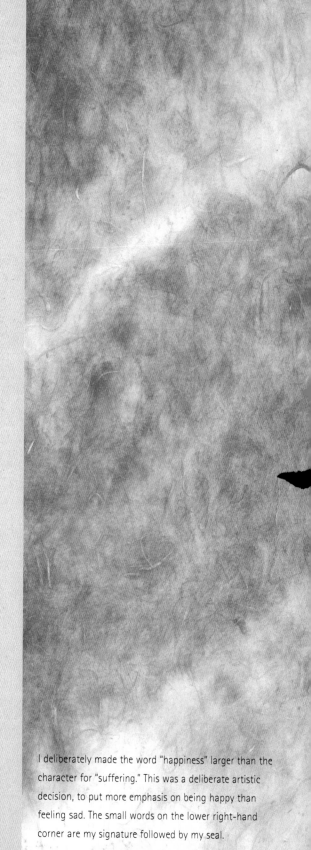

I deliberately made the word "happiness" larger than the character for "suffering." This was a deliberate artistic decision, to put more emphasis on being happy than feeling sad. The small words on the lower right-hand corner are my signature followed by my seal.

藥中苦

LESSON 14 Diagonal Brushstroke to the Left

This brushstroke has many different forms, which depend on how the Chinese word is being presented. Even with the same word, different artists may use different variations of the diagonal brushstroke to the left. In this lesson and the next, we will deal with the most common forms. When constructing this brushstroke, pay special attention to Steps 3 and 4, as these are, in fact, one continuous move. I break it up to draw your attention to the pressing at the beginning of Step 4. It is this pressing that makes the brushstroke so beautiful, with a slim body and a thicker ending.

Anatomy of a diagonal brushstroke to the left

The process of writing a diagonal brushstroke to the left can be broken down into four steps. Remember that all steps are connected in a continuous process; your brush should not leave the paper between steps.

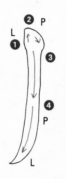

Four steps to a diagonal brushstroke to the left

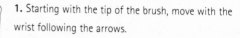

1. Starting with the tip of the brush, move with the wrist following the arrows.

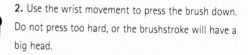

2. Use the wrist movement to press the brush down. Do not press too hard, or the brushstroke will have a big head.

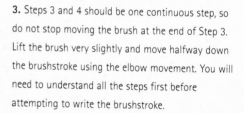

3. Steps 3 and 4 should be one continuous step, so do not stop moving the brush at the end of Step 3. Lift the brush very slightly and move halfway down the brushstroke using the elbow movement. You will need to understand all the steps first before attempting to write the brushstroke.

4. Press a little bit more to thicken the lower part of the brushstroke, then gradually lift the brush as you move toward the end.

Repeat the four steps in a continuous process.

Types of diagonal brushstroke to the left

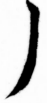

Vertical form

Both the words "'moon" and "fly" on the opposite page use this form of the brushstroke.

Long curved form **Short curved form**

When the curved forms are used, they are always written so as to mirror diagonal brushstrokes to the right. The long form is used in words like 春 (see page 88) and 天 (see page 83). The short form is usually used when the diagonal brushstroke to the left crosses with the diagonal brushstroke to the right, for instance 父 (see page 88) and 又 (see page 85).

Pointed form

The pointed form is written without Step 1. It is often used in Hsing Shu script because it is a quicker way to write this brushstroke. 風 on the opposite page is an example.

Forming words

The following are good examples of Chinese words
which use the variations of the diagonal brushstroke to
the left. Other examples can be found in Sheet 4 (see
pages 88-89).

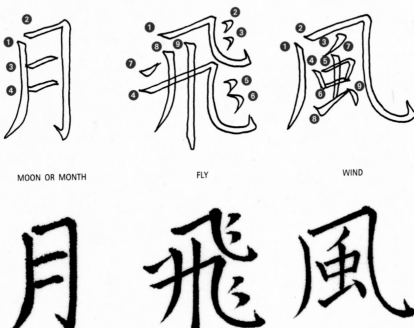

MOON OR MONTH FLY WIND

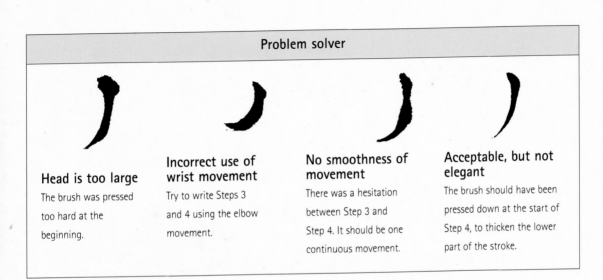

Problem solver

Head is too large

The brush was pressed
too hard at the
beginning.

**Incorrect use of
wrist movement**

Try to write Steps 3
and 4 using the elbow
movement.

**No smoothness of
movement**

There was a hesitation
between Step 3 and
Step 4. It should be one
continuous movement.

**Acceptable, but not
elegant**

The brush should have been
pressed down at the start of
Step 4, to thicken the lower
part of the stroke.

15 Angled Diagonal Brushstroke to the Left

The angled forms are identical in construction to the press and lift downward brushstrokes. The shorter forms are exactly the same, and the long forms are simply longer. The anatomies of all these forms, as well as the combined horizontal brushstroke and angled form, are given in this lesson. The round end variation is a special brushstroke, and I will discuss this variation in detail.

Anatomy of long angled form

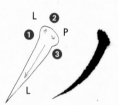

Anatomy of short angled form

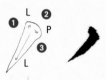

Anatomy of horizontal angled form

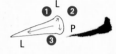

Anatomy of combined horizontal brushstroke and angled form

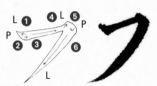

The round end angled form

Words like 行 and 形 have two or three parallel, diagonal brushstrokes. However, if you write them all in the same form and at the same angle, the presentation will look very formal and dull. Calligraphers prefer to write them so they point in slightly different directions. They also do not like to have too many pointed brushstrokes in a single word, so they write the uppermost one with a round end. So a word with three parallel diagonal brushstrokes to the left, like the word 形, will have a round-end short-angled form at the top, followed by a slightly longer pointed form pointing at a slightly lower angle. The last angled brushstroke will be a long pointed one. This practice presents the word in a more lively way. In a word like 行, with two parallel angled brushstrokes, the first will have a round end, and the second will be in pointed form. Both brushstrokes will point to slightly different angles.

Anatomy of a round end angled diagonal brushstroke to the left

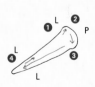

The technique for this brushstroke can be broken into four steps. It is a continuous process, done without removing the brush from the paper.

Four steps to a round end angled diagonal brushstroke to the left

1. Start with the tip of the brush, and move with the wrist following the arrows shown in the anatomy diagram.

2. Use a wrist movement to press the brush down. Do not press too hard or the brushstroke will have a big head.

3. Move the brush with the elbow movement in the direction indicated. Lift the brush gradually toward the end of the brushstroke. When you reach the end of the brushstroke press slightly before Step 4.

4. Lift the brush, and move with the wrist back to the body of the brushstroke in the direction indicated. Do not press at this stage or you will spoil the shape of the brushstroke.

Repeat the steps in a continuous process.

Forming words

Pay attention to the word "plenty." It has many angled diagonal brushstrokes to the left. Notice how different lengths are used, each one in a slightly different direction.

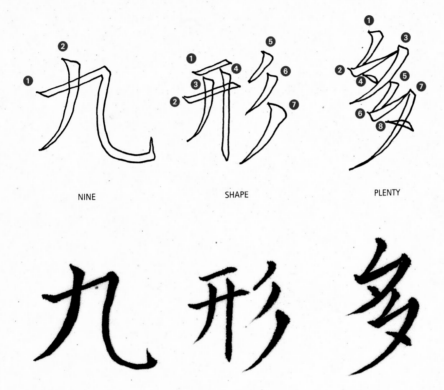

NINE SHAPE PLENTY

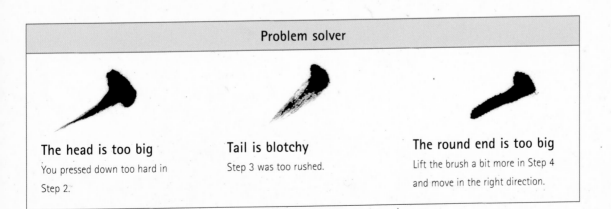

Problem solver

The head is too big
You pressed down too hard in Step 2.

Tail is blotchy
Step 3 was too rushed.

The round end is too big
Lift the brush a bit more in Step 4 and move in the right direction.

5 Wishing Someone Success in a New Career

This is a project that can be used to wish a friend, or even yourself, the best of luck in a job. The four words in the Chinese proverb literally say "Steady steps to clear sky." What they mean is rising to the top without hurdles – or, as we would say in the West, "Wishing you every success."

In this example the four Chinese words are written on cotton paper, with a pattern representing heaven printed in the background. For information and instructions on how to mount your Xuan paper artwork with thicker paper, see page 132.

You will need:

- Long tip, goat-hair Large Script brush
- Any Xuan paper or cotton paper
- Ink

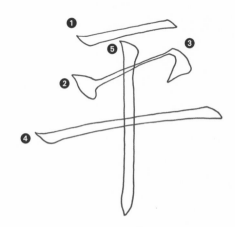

LEVEL OR STEADY

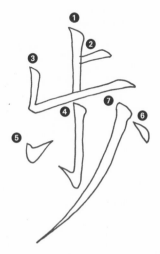

STEPS

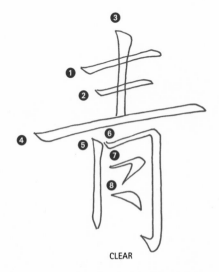

CLEAR

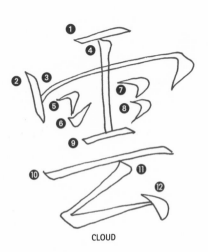

CLOUD

Diagonal Brushstroke to the Right

We are coming not only to the last group of brushstrokes but also to the most interesting ones. The diagonal brushstroke to the right has many different forms for use in different words. Calligraphers also use various brushstrokes for the same word on different occasions to bring out the mood of the writing. In this lesson, we will look at the standard version.

Anatomy of a standard diagonal brushstroke to the right

The process of writing a standard diagonal brushstroke to the right can be broken down into four steps, each using a press (P) or lift (L) action with the brush, as shown in the diagram. Remember that all steps carry on straight after the other, so that the brush does not leave the paper.

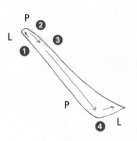

Four steps to a standard diagonal brushstroke to the right

1. Starting with the tip of the brush, move with the wrist following the arrow shown in Step 1.

2. Use the wrist movement to press the brush slightly downward. Do not press too hard or the brushstroke will end up with a head that is too large.

3. Using an elbow movement, move as shown in the anatomy diagram for Step 3. Gradually increase the pressure as you move down so that the brushstroke will slowly widen.

4. Use the wrist movement and gradually lift the brush following the arrow until the ending is pointed.

Repeat the four steps in a continuous process.

Types of diagonal brushstroke to the right

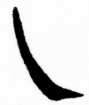

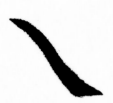

Long form Short form

These two forms are used more often than the others. They are used according to the size of the brushstroke required in a word. For example, the word "heaven" on the next page requires the long form, while the word "good" requires the short form.

Curved form

The curved form is mostly used when a heading like ∧ is required for a word. The character for "gold" on the opposite page is a good example.

Pointed form

The pointed form is written without Step 1. In Hsing Shu this form often replaces the long form or short form in order to speed up the writing.

Forming words

Sometimes it is confusing to try to work out which form
to use for each word. Hopefully these three examples will
show you how a particular variation is chosen.

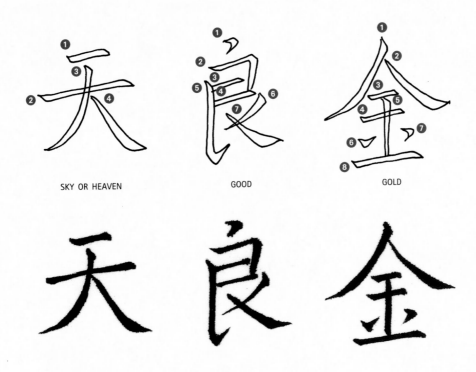

SKY OR HEAVEN · GOOD · GOLD

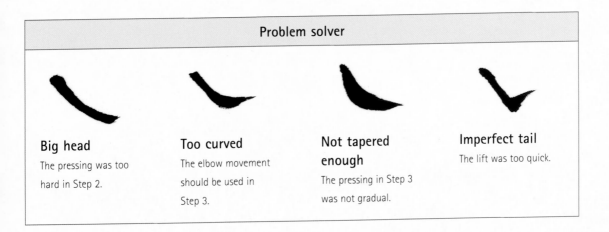

Problem solver

Big head
The pressing was too
hard in Step 2.

Too curved
The elbow movement
should be used in
Step 3.

**Not tapered
enough**
The pressing in Step 3
was not gradual.

Imperfect tail
The lift was too quick.

17 Horizontal Form of the Diagonal Brushstroke to the Right

The long and pointed forms of the diagonal brushstroke to the right can be written horizontally. The steps for writing them are the same as the angled forms in Lesson 16, with the positions changed from angled to horizontal. In this lesson, we will concentrate on the horizontal form with a head. This is the most commonly used brushstroke among the horizontal forms.

Anatomy of diagonal brushstroke to the right in horizontal position

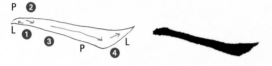

Anatomy of pointed diagonal brushstroke to the right in horizontal position

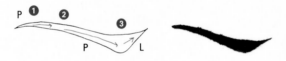

Anatomy of a horizontal form of diagonal brushstroke to the right with a head

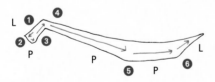

Six steps to a horizontal form of diagonal brushstroke to the right with a head

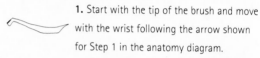

1. Start with the tip of the brush and move with the wrist following the arrow shown for Step 1 in the anatomy diagram.

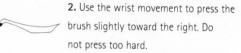

2. Use the wrist movement to press the brush slightly toward the right. Do not press too hard.

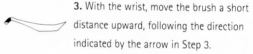

3. With the wrist, move the brush a short distance upward, following the direction indicated by the arrow in Step 3.

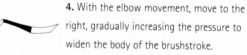

4. With the elbow movement, move to the right, gradually increasing the pressure to widen the body of the brushstroke.

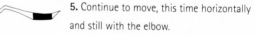

5. Continue to move, this time horizontally and still with the elbow.

6. Lift the brush gradually with the wrist in the direction of the arrow in Step 6 until the ending is pointed.

Repeat the six steps in a continuous process.

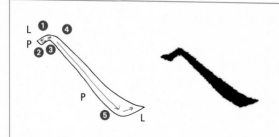

Angled form with a head

The angled form of the diagonal brushstroke to the right sometimes has a head. For instance, the word "also" on the next page. The anatomy of this form and the written brushstroke are shown on the left. Note that Step 5 of the horizontal form is missing.

Forming words

The three words chosen here are representative of the brushstrokes learned in this lesson. More will be given in Sheet 4 (see pages 88–89).

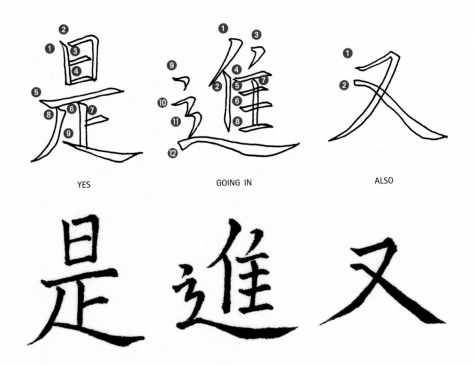

YES GOING IN ALSO

Problem solver

The head is too big
The brush was pressed down too hard in Step 2.

No elbow movement
A wrist movement should not have been used in Steps 4 and 5.

Slanting horizontal
The last brushstroke should be horizontal.

Stretched brushstroke
The last brushstroke is too long. Try to control your movement.

LESSON 18 Round End Form of the Diagonal Brushstroke to the Right

The round end form of the diagonal brushstroke to the right curves down rather than up. The rule is that a single word should never carry two standard forms of the diagonal brushstroke to the right; one of them, usually the left or upper one, is replaced either by a dot or the round end form described in this lesson. When writing Hsing Shu, at speed the angled form (see page 82) is also often replaced by this form.

Anatomy of the round end form of diagonal brushstroke to the right

The process of writing a round end form can be broken down into five steps, which are written as a continuous process.

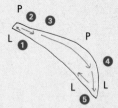

Five steps to the round end form of a diagonal brushstroke to the right

1. Starting with the tip of the brush, move with the wrist following the arrow of Step 1.

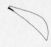

2 Use the wrist movement to press the brush down. Do not press down too much.

3. Using the elbow movement, move in the direction indicated by the arrow in Step 3. Gradually increase the pressure to widen the body of the brushstroke, and curve downward.

4. Continue to move down with the wrist, gradually lifting the brush.

5. Using the wrist movement, move the brush back into the body of the brushstroke. This reverse step creates the rounded end.

Repeat the five steps in a continuous process.

When to use the rounded form

Word A means "wood," as in the material. It has a diagonal brushstroke to the right. This word is also a part of many other words.

Word B means "wood," as in a small forest. It is made by writing Word A twice. Notice that one of the diagonal brushstrokes to the right has been replaced by a dot.

Word C means "forest." It is made up of three Word A's. It should have three diagonal brushstrokes to the right, but one is replaced by a dot and the other by a round end form. When a word is written quickly in Hsing Shu, like the **word D** meaning "fruit," the round end form is often used instead of the angled form.

Other rounded forms

The long and horizontal forms can also be written with round ends. In Hsing Shu, the last character in a piece of writing uses one of these forms to give a solid end to the message.

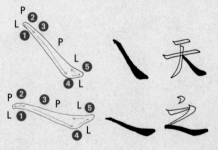

Forming words

Hsing Shu always uses round end forms, learned at the beginning of this lesson, to replace the angled ones if the word is written quickly. The word "eat" is an example of this. The word "very hot" has the upper diagonal brushstroke replaced by a round end form.

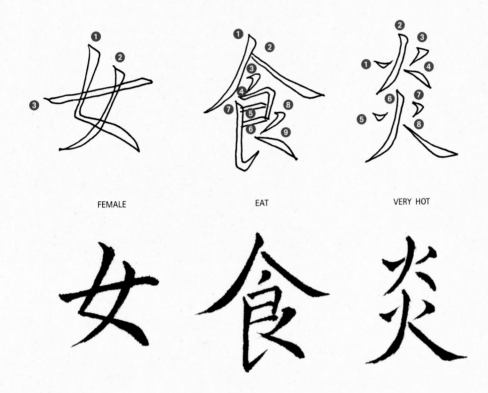

FEMALE EAT VERY HOT

Problem solver

The head is too big

The brush was pressed down too hard in Step 2.

Incorrect ending

In the last step, the brush was lifted too quickly and in the wrong direction.

Too horizontal

The angle of the main part of the brushstroke is incorrect.

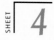

4 More Chinese Words to Try

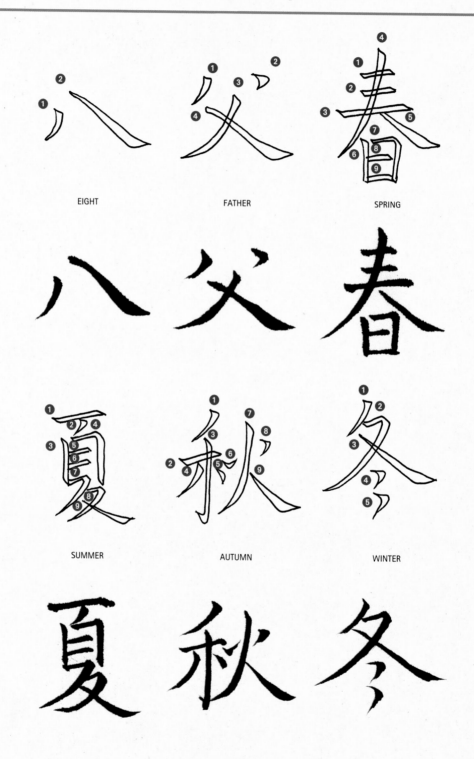

EIGHT

FATHER

SPRING

SUMMER

AUTUMN

WINTER

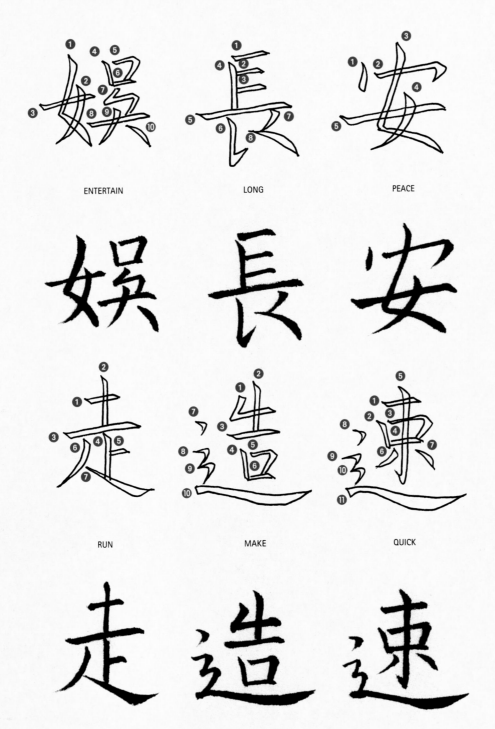

ENTERTAIN LONG PEACE

RUN MAKE QUICK

89

6 Wedding Wishes

The meaning of the four words used in this project is "a union created in heaven." This is a popular expression, similar to the English "a match made in heaven," which is usually written for use as a centerpiece at a Chinese wedding party. You can also write these words in small sizes on a card and send it to your friends to celebrate their wedding or anniversary.

This gold-pattern paper is appropriate as it symbolizes good news. The four words should be written in this order, reading right to left. For information and instructions on how to mount your Xuan paper artwork with thicker paper see page 132.

You will need:

- Long tip, goat-hair Large Script brush
- Cotton paper with a gold pattern of a pair of dragons printed on it. You can also use plain Xuan paper.
- Ink and ink reservoir

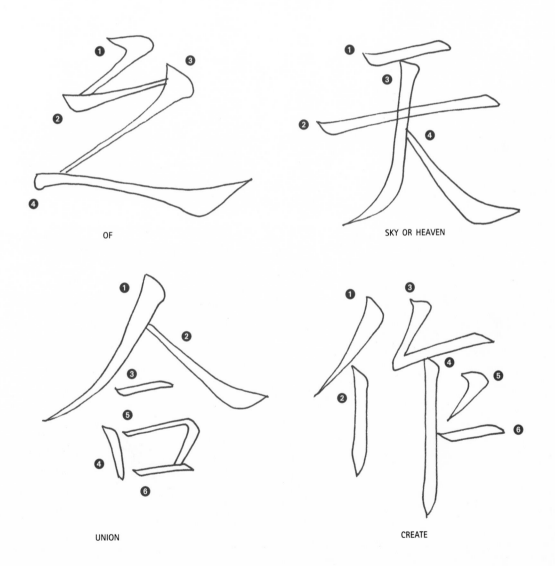

OF

SKY OR HEAVEN

UNION

CREATE

LESSON 19 Using All the Brushstrokes to Write "Lasting"

The word for "lasting" has a special significance in Chinese calligraphy, as it is written with each of the basic brushstrokes. The diagram below shows you the eight different brushstrokes that make up the word.

When I was studying calligraphy, my teacher used to make me practice this word for hours, time after time. It was the warm-up exercise for each lesson to get my hand and arm moving in the right way. I would start with Small Script, go on to Large Script, and finish with Big Writing.

You can use this method for the important task of practicing basic brushstrokes. If you are serious about calligraphy, you should practice all the basic brushstrokes with their variations as often as possible. If you have only limited time, at least practice the eight most basic ones as much as you can.

Using this word makes practice more interesting—and it is a word that is very useful when writing greeting cards, as we will discover in Project 7 (see page 94).

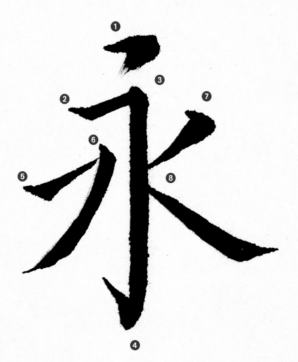

1. Dot

2. Horizontal brushstroke

3. Vertical brushstroke

4. Hook

5. Press and lift upward

6. Diagonal brushstroke to the left

7. Press and lift downward

8. Diagonal brushstroke to the right

Forming words

These four words written below together mean
"love that lasts forever" or "everlasting love." They
are the ideal words, perhaps, for a Valentine's or
anniversary card.

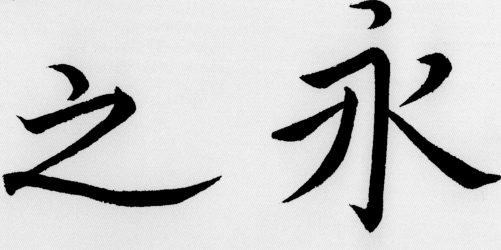

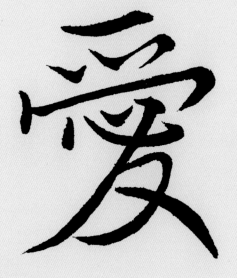

OF

LASTING

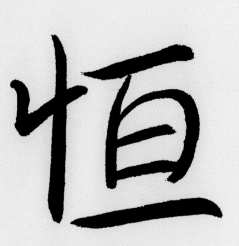

LOVE

FOREVER

7 A "Lasting" Greeting Card

If you write the word "lasting" on a greeting card to your friend, you extend the greeting to be a "lasting" one, meaning your wishes last forever.

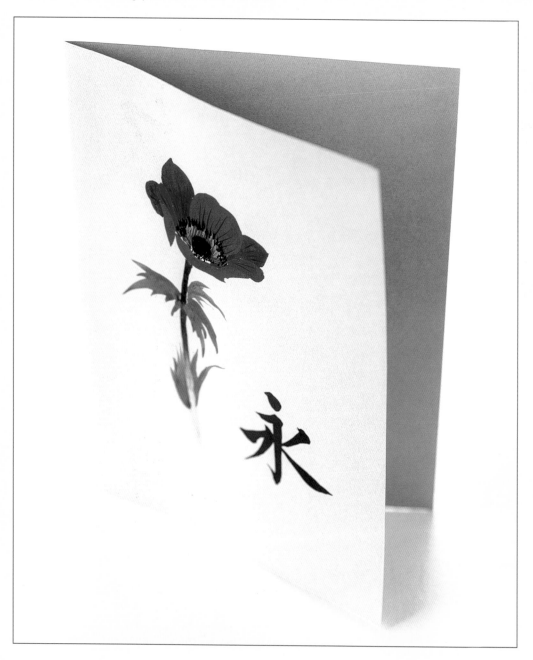

A card with a drawing of a heart or a rose on it expresses love. By adding the word "lasting," you are saying that the love that you send will be everlasting.

Similarly, an anemone symbolizes "friendship." A card with an anemone and the word "lasting" sends a declaration of "lasting friendship." Let us make a card like this.

You will need:

- Letter-sized (A4) sheet of card
- Watercolor brush for painting
- Watercolors (I used alizarin crimson, mauve, sap green, and black for the illustration card pictured)
- Small Chinese brush for writing
- Ink or the watercolor black

Four steps to making a "lasting" card

1. Fold the card in half. Place on a flat surface with the opening facing to the right.

2. Sketch a drawing of an anemone. You can use the illustration in this project as a model, or you may prefer to draw your own version.

3. Add colors to the drawing with the watercolor brush and paint.

4. Dip the small Chinese brush into the ink or the black watercolor. Write the word "lasting" next to the anemone.

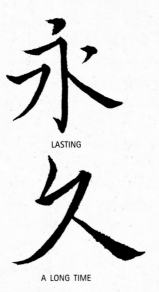

LASTING

A LONG TIME

You might like to write the words above instead. Together they mean "lasting for a very long time."

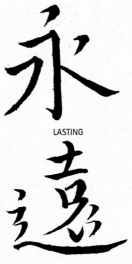

LASTING

STRETCHING A LONG TIME

Above is another alternative. Together these words also mean "lasting for a very long time."

Five
The Five Golden Rules

These simple rules ensure that each brushstroke in a word is written in the right order. The guidelines not only make for a more structured approach to writing, but they also help achieve the essential balance needed in the overall composition of a word.

平步青雲

20 Golden Rule 1: Start with the upper part of a word, then move downward

Lessons 20 to 25 deal with the rules used for building Chinese words. These guidelines should allow you to work out the order of each brushstroke in any new word you come across – however complicated its construction.

Unsurprisingly, there are exceptions to all of these rules, but usually there are logical explanations. However, if you come across some cases that contradict all these rules, the best advice is to follow common sense and your natural writing movement.

Most of the examples to follow are ones you have already learned. However, there are three new words at the end of each lesson, for which I will give clear instructions as to the order they should be written.

Simple words

Rule 1 is based on common sense. Building a word from top to bottom gives you a sense of order. When faced with a new word, you will know where to begin. Let's start with some words that are clear examples.

THREE WINTER

Before going any further, you need to understand how we describe the overall structure of Chinese characters. For the purpose of teaching, I divide words into units and levels. Units are parts of a word that sit side by side. Levels are parts of a word that sit on top of one another.

Words with more than one unit

The word "clear" has two units, a left unit 冫 and a right unit 青. The right unit has two levels: 主 and 月. This is not a rule, as I have said, just a useful classification to use when learning the rules.

CLEAR

For a word made up of more than one unit, the left unit is written first. We will discuss this in Golden Rule 2 (see page 100), but Rule 1 still applies within each unit.

Left Right
unit unit

RED AUTUMN

Some exceptions to the rule

Each of these two words has a center brushstroke
running from top to bottom. This brushstroke is usually
written last. There are more examples in Golden Rule 3
(see page 102).

Words with a closed or open box

In writing boxes, always begin with the left brushstrokes.

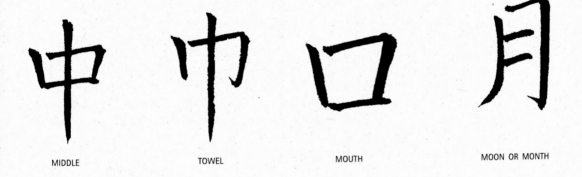

MIDDLE TOWEL MOUTH MOON OR MONTH

New words for practicing this rule

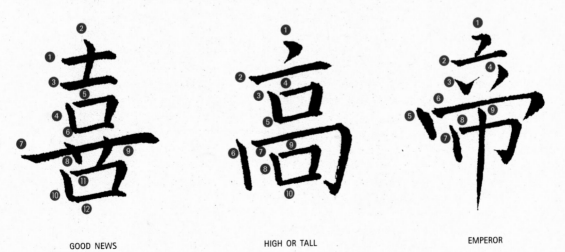

GOOD NEWS HIGH OR TALL EMPEROR

21 Golden Rule 2: Start with the left part of a word, then move to the right

All Chinese words start from the left and move to the right. Writing this way is natural if you are right-handed. Left-handed people, however, may find this uncomfortable. Remember, the writing process was established and all these rules were made before left-handedness was accepted. In my experience, a left-handed person can learn to write Chinese just as well as a right-hander.

There are two important aspects of this rule. The first is that when a word has more than one unit, the left unit is written first. The second is that when the brushstrokes are on the same level, start with the left brushstroke and then move to the right. A good example is the word "well" (as in water well). The two vertical brushstrokes are at the same level, so the left one is written before the right one.

A word with two
vertical brushstrokes
WELL

A word with two
dots at the same level
OCEAN

For words with a group of two, three, or four dots, always start by writing the dot furthest to the left. Examples are the words "ocean," "red," and "dot."

A word with three
dots at the same level
RED

A word with four dots
at the same level
DOT

Simple words

Let's revisit some words you have already learned that are obvious examples of this rule. Don't forget that, at the same time, Rule 1 applies. The brushstrokes of "heart" and "eight" are written from left to right.

HEART EIGHT

Words with two units each

For these words, finish writing the left unit before starting the right one. Other rules will apply in writing each unit.

RED AUTUMN

Words with more than two units each

For these words, you start with the unit on the left, and then move one unit to the right at a time. The instructions for writing these two examples are given at the bottom of the page.

Words with groups of dots separated by brushstrokes

Some words have groups of dots as part of them. If a group of dots has a line of movement connecting them (see page 50), it is better to write these dots one after another to express the line of movement. If there is one or more brushstrokes separating them, as in these examples, the obvious method is to write the brushstrokes before or after the group of dots.

CONTINENT STREET

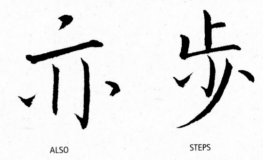

ALSO STEPS

New words for practicing this rule

CONTINENT STREET ROAR

22 Golden Rule 3: Horizontal brushstrokes precede vertical brushstrokes

This rule is straightforward enough to understand when dealing with words like those given in the "simple words" section below. However, it may seem confusing with words that have many different levels of horizontal and vertical brushstrokes. So to clarify the rule here is a fuller definition: "At each particular level, the horizontal brushstroke is written before the vertical brushstroke."

Simple words

These are some of the words you already know that clearly illustrate Rule 3; in each, the horizontal brushstrokes are written before the vertical ones.

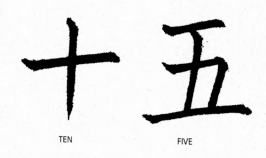

TEN FIVE

The word for "long life"

The word for "long life" (see right) can be divided into four levels. It is a good example of how Rule 3 should be applied level by level, rather than to the word as a whole.

Top level

The two short horizontal brushstrokes are written before the vertical brushstroke (Rule 3). The last horizontal brushstroke is written last because it is at the bottom of this level (Rule 1).

Second level

The second level is a box. To write a box, always start with the left brushstroke.

Third level

There is only one brushstroke in this level.

Bottom level

The bottom level has two units. Start with the left unit. It is a box and can be written in the same way as the second level. Next move to the right unit. Start with the horizontal brushstroke and finish the rest.

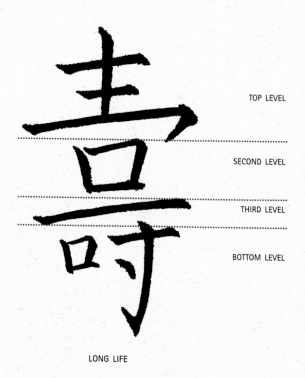

TOP LEVEL

SECOND LEVEL

THIRD LEVEL

BOTTOM LEVEL

LONG LIFE

More words with multiple levels of brushstrokes

Try working these out in the same way as the word "long life." Then see whether your approach agrees with the instructions given previously in the book (see Sheet 1 and Lesson 8).

Words with brushstrokes going through the center

In Lesson 20, I discussed words that have a brushstroke running from top to bottom. This brushstroke is usually written last. Instructions for writing these new words are given below.

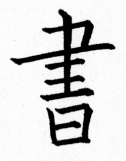

BOOK OR WRITING

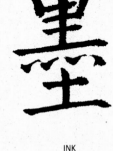

INK

BRUSH

CAR

New words for practicing this rule

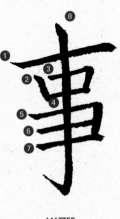

MATTER

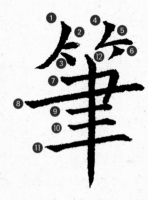

BRUSH

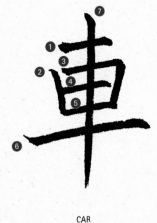

CAR

Golden Rule 4: Diagonal brushstrokes to the left precede diagonal strokes to the right

In the majority of cases, if there is a diagonal brushstroke to the right in a word, there is also a diagonal brushstroke to the left. You will also find that the one to the left is always left of the one to the right; the word would look out of balance if it were the other way round. Applying Rule 2, the brushstroke on the left will be written before the one to the right—this becomes Rule 4.

Simple words

In some of the simple words that you have already come across, Rule 4 is simply just a direct application of Rule 2. The diagonal brushstroke on the left is written before the one on the right side of the word.

Words with crossing diagonal brushstrokes

This is a good example of why Rule 4 is needed in addition to Rule 2. It makes it completely clear that the diagonal brushstroke to the left in the cross pattern is drawn first.

EIGHT

UNION

ALSO

FATHER

Words with horizontal forms of the diagonal brushstroke to the right

A horizontal form is always written last in a word, so Rule 4 has no direct influence on the outcome.

YES

GOING IN

The word "female"

In this word, a diagonal brushstroke to the left seems to be written after the one to the right. In fact, the left brushstroke is a combination of the two diagonal brushstrokes, with a diagonal brushstroke to the left merging into a diagonal brushstroke to the right. This combination is written before the simpler diagonal brushstroke to the left. The same L-shape (highlighted in black in the diagrams to the right of each word) is also used in the word for "peace."

FEMALE PEACE

New words for practicing this rule

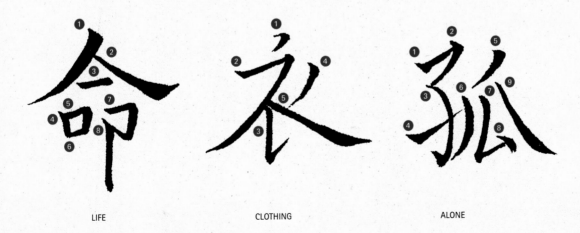

LIFE CLOTHING ALONE

24 Golden Rule 5: The box rule—finish everything inside the box before closing it

As we have previously discussed, a box always starts with the left-hand side brushstroke. The rule in this lesson refers to a closed box. "Closing a box" correctly means adding the bottom brushstroke of the box after the brushstrokes inside the box have been written.

What is a "closed box"?

A "closed box" is simply a box with four sides. It is usually made up of three brushstrokes – a vertical brushstroke for the left side of the box, a combined horizontal and vertical brushstroke for the top and right sides, followed by a simple horizontal brushstroke for the box base. A structure is called an "opened box" when one of the sides is missing.

Words with contents inside the box that extend above the box

When this happens, the brushstrokes that extend above the box are treated as contents inside the box and must be written before the closing brushstroke of the box. The brushstroke order for these two examples is given on the page opposite.

"A CLOSED BOX" "AN OPEN BOX"

WINE WEST

Simple words

I will begin with two simple words you are already familiar with. The box rule is illustrated very clearly in these examples.

Exception 1: Words with contents inside the box that extend below the box

Words with brushstrokes extending below the box are written after the box is closed.

FOUR FIELD 10,000 FRUIT

Exception 2: Words with brushstrokes going through the box

These brushstrokes are written after the box.

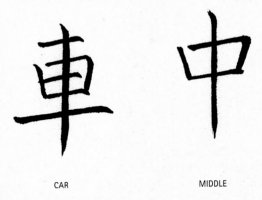

CAR MIDDLE

Exception 3: The word for "mother"

This is a special exception. The word "mother" is written with the box closed before the contents are filled in. The box is constructed using two combined horizontal and vertical brushstrokes. This process leaves no opening, which is why the contents are added later. Any word with "mother" as part of it (such as "sea") is written in the same way.

MOTHER SEA

New words for practicing this rule

WINE

WEST

DRAWING

25 Using the Golden Rules

In this lesson, we'll use all five golden rules to work out the order of brushstrokes in writing two words. The first word means "difficult"—and it might look difficult to write, but the secret is to break complex words into their levels and units, so that you can write them step-by-step.

DIFFICULT

Step 1

The word for "difficult" has three units. We'll start by tackling the first unit (Rule 2).

Step 2

The first unit has two levels. We'll construct the upper one first (Rule 1).

First unit Second unit Third unit

First level Second level

Step 3

This level has two parts. We'll construct the upper part first (Rule 1). The horizontal brushstroke will be written before the two vertical brushstrokes in this part (Rule 3). The bottom brushstroke will be written last (Rule 1).

First part **Second part**

Now we can label the brushstrokes of this level.

Step 4

In the second level of the first unit, the diagonal brushstroke to the left runs through the box and the two horizontal brushstrokes, so the box and the two horizontal brushstrokes will be written first (Rule 5). The diagonal brushstroke to the right will be written after the diagonal brushstroke to the left (Rule 4). We will begin with the box as it is uppermost (Rule 1).

Step 5

The left brushstroke of the box will be written first (Rule 5 and Rule 1). The horizontal brushstroke at the bottom will be last (Rule 1). The two horizontal brushstrokes will be written next.

Now we can label the brushstrokes of this level (carrying on the numbering from where we left off with the first level).

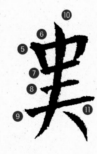

Step 6

For the second unit, the upper brushstroke is written before the lower brushstroke (Rule 1). We can label the two brushstrokes of this unit.

Step 7

The third unit has two identical levels. Let's start with the upper level (Rule 1).

Upper level Lower level

Step 8

This level has two parts. For the upper part, the horizontal brushstroke will be written before the vertical brushstroke (Rule 3). Finish this part with the bottom horizontal brushstroke (Rule 1). The lower part is written in the same order.

Upper part Lower part

Now we can label all the brushstrokes in this unit.

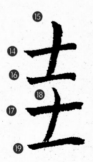

The final sequence

Finally, we can bring all the labels together. The order of all the brushstrokes for the word "difficult" is set out below.

A puzzle to solve

Now take a shot at trying to work out which order to
paint the brushstrokes in the word for "win." Start off
breaking the word into its units and levels, and then
follow the five golden rules. Good luck!

WIN

For the very enthusiastic calligrapher, why not start to
unravel the word "orchid."

ORCHID

Six

The Five Styles of Chinese Calligraphy

All of the five main styles of Chinese calligraphy are still popular today, although most of them are used solely for artistic purposes. The lessons and projects in this chapter are designed to give you a taste for these beautiful scripts.

風松影竹

The Different Scripts

Five styles dominate Chinese writing. The choice in calligraphy is generally a matter of taste. Their different appearances and approaches mean that one may be favored by the individual calligrapher over the others, while others might be used for artistic reasons on particular projects.

Chuan Shu

Chuan Shu, or seal script, is believed to be the earliest well-developed style of Chinese writing. Words are simple, almost primitive. All brushstrokes are uniform and the same width throughout. Beginnings, corners, and endings are round. Emphasis is on vertical brushstrokes so words are tall and thin. Most surviving artefacts of Chuan Shu are inscriptions on stones or brass, and it remains to this day the most popular style for carving on seals.

Kai Shu

Kai Shu, or pattern script, is the most formal of the five styles. Words are almost square in shape. Every dot and line is highly structured and stylized. Kai Shu is always referred to as the "Real Shu," and it is recognized as the standard for Chinese writing. The modern printing script is a variation of this style.

Li Shu

Li Shu, or clerkly script, emphasizes the horizontal brushstrokes, so words are wide. The horizontal brushstrokes are distinctive through their emphasis of their two ends, particularly the right-hand one which always ends with a triangular shape. The style is very light and has a swinging feel.

Tsao Shu

Tsao Shu, or grass script, simplifies all the brushstrokes in fluent, flying movements, with few corners. Very often a single new gliding brushstroke represents many traditional ones; different words can even be connected together in a piece of writing. "Tsao" is the Chinese word for "speed." It is an extremely artistic script which is still very popular today.

Hsing Shu

Hsing Shu, or running script, is derived from Kai Shu. It is the most modern of all the scripts, and is the one that is the most commonly used today.

The word "rain" written in each of the five main
styles of Chinese calligraphy

CHUAN SHU

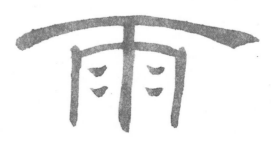

LI SHU

TSAO SHU

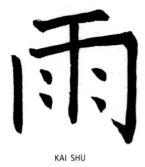

KAI SHU

HSING SHU

26 Chuan Shu

Chuan Shu is a ceremonial style that is traditionally used for carving. The tall, condensed script is very elegant and is therefore also a favorite for the creation of artwork. Modern scholars like to use it for headings on paintings and for official scrolls, as well as for calligraphy.

Writing Chuan Shu

During the height of Chuan Shu's popularity, the modern Chinese calligraphy brush had not been invented. The brushes used then were probably just simple bunches of hair tied together and had very blunt tips. Today brushes have pointed tips, and it is very difficult to achieve round ends with pointed brushes.

Many attempts have been made to duplicate the blunt effect of a brush—some scholars cut off bits of the brush tip, while others burn the tip to make it rounder. In fact, the best and simplest solution is to use worn-out brushes that have lost their pointed tips (this is why artists never throw away an old brush).

Using a relatively new brush to write a Chuan Shu-style brushstroke with its rounded endings requires some skill and practice. Use a wolf-hair brush rather than a soft-hair one.

The trick is a small looping movement with the brush. Take the horizontal brushstroke as an example. Usually you would write from the left to the right. This time you start the brushstroke a little away from the beginning. Press the brush tip and move the brush to the left where the beginning of the brushstroke is, then immediately move the brush to the right to finish the brushstroke. Maintain the same constant pressure on the brush to achieve a consistent width.

This reversing technique at the start of a brushstroke to achieve a round end is usually indicated by the symbol ↶ .

Anatomy of a horizontal brushstroke in the Chuan Shu style

Distinctive characteristics

1. All brushstrokes are of a uniform width. There is no pressing or lifting of the brush to create variation in a brushstroke.

2. All beginnings, endings, and corners are rounded.

3. Emphasis on each word is on the vertical brushstroke. A word in the Chuan Shu style is longer than it is wide; the proportion of height to width is approximately 3 to 2.

Personal project using Chuan Shu

I wrote these three words meaning "blessing," "rewards for doing good," and "long life" on tiles using ceramic paints. Blessings, rewards for doing good and long life are considered to be ingredients of a very full and happy life. These tiles will enhance any wall. If you use ceramic paint for this project, make sure that you follow the manufacturer's instructions.

The diagrams below show you how to write these words. The numbers are the order of brushstrokes. Loop marks like this ⌐ indicate where the reversing technique is required in order to create a rounded beginning to the brushstroke. In places where two brushstrokes join, this looping movement is unnecessary.

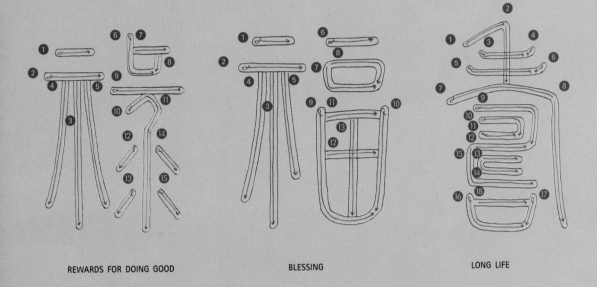

REWARDS FOR DOING GOOD BLESSING LONG LIFE

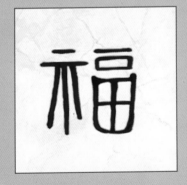
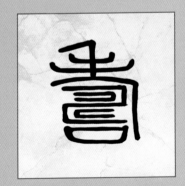

27 Li Shu

"Li" is the Chinese word for servants or slaves. According to legend, when the Qin Dynasty emperor was desperate to find an alternative style of calligraphy to meet the increasing demand for writing, a slave invented this style and it was immediately adopted as the official script. Few scholars actually believe the story, because a style of calligraphy can't just be invented overnight. The more accepted explanation is that Li Shu appeared some time before the Qin Dynasty. It was used not by scholars and officials but by traders, merchants, and servants because it was easier to understand and to write.

Writing Li Shu

Pressing and lifting techniques are often used in Li Shu, but the beginnings of a brushstroke can be pointed or blunt. For blunt beginnings, use the reversing technique described in Chuan Shu (see page 116). Take the horizontal brushstroke as an example. The beginning is blunt so the reverse technique is used, but the exaggerated triangular end to the right is done by pressing and lifting. Corners are square as they are written as two separate brushstrokes. I recommend using the goat-hair brush for this script.

Anatomy of a horizontal brushstroke in Li Shu style

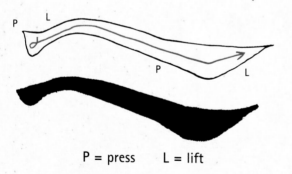

P = press L = lift

Corners in Li Shu style

Distinctive characteristics

1. Its brushstrokes depart from the uniform widths of Chuan Shu, partly because modern brushes were available when it was invented. Pressing and lifting techniques using brushes create the different shapes.

2. The words are extended—they are wider than they are high, as the emphasis is on the horizontal brushstrokes. It is believed that at the height of its popularity, Li Shu was used for recordings on bamboo slats. Writings were usually done vertically on a long piece of bamboo slat. The process of trying to squash as many writings as possible onto a bamboo slat made the words flatter and extended them sideways.

3. The horizontal brushstrokes have distinctive ends, particularly the right-hand one, which is always triangular in shape.

4. All corners are square.

Personal project using Li Shu

I used emulsion paint to write the words "peace" and "happiness" on separate wooden boards. When the words were dry, I varnished the whole surface of the wood, so that I could use the boards for serving food. The following diagrams show you how to write the words. The numbers indicate the order for writing the brushstrokes. When the words "peace" and "happiness" are used together, in this order, they mean "contentment."

The two finished serving boards. The two characters together symbolize "contentment."

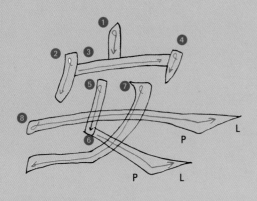

PEACE

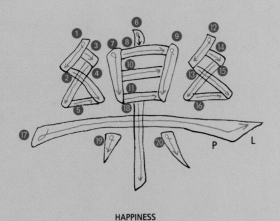

HAPPINESS

LESSON 28 Tsao Shu

Tsao Shu was developed at more or less the same time as Li Shu, but it was not as widely used because it was more difficult to master. A Chinese word written in this style has many brushstrokes merged together as a single fluent one. Although there are rules for how to simplify the brushstrokes, the outcome can vary according to the artist's mood and the desired artistic presentation. During the period of Tsao Shu's popularity, each Chinese word was still written separately, as in all the other styles. However, from the Tang Dynasty onward, scholars started a fashion to link some of the words together.

Writing Tsao Shu

Tsao Shu is written relatively fast in order to keep the brushwork flowing. Experienced artists prefer to use tough brushes with extra long tips. The handles for these brushes are usually longer than usual; this allows you to hold the brush farther away from the tip so that you can swing the brush. If you do not have a brush like this, use a long tip, wolf-hair Large Script brush or, alternatively, a goat-hair Large Script brush.

Pressing and lifting is essential for this style. Your hand and arm are always kept away from the surface when you are writing so that there is no restriction to the movement. Wrist and elbow movements are used in tandem.

To achieve an artistic presentation, words in Tsao Shu writing do not need to be the same size—some may be exaggerated, while some may be reduced.

I am not going to list any rules for the simplification of brushstrokes, as there are so many of them. Beginners usually have a Tsao Shu dictionary to guide them.

Distinctive characteristics

1. The distinctive character of Tsao Shu is its continuous movement. Writing Tsao Shu is like writing a continuous line, broken up at different places to form separate brushstrokes.

2. Though there are gaps between brushstrokes, the line of movement running through a word is flowing. In the modern form of Tsao Shu, the line of movement sometimes runs through the whole passage.

3. In an artistic presentation, you will always notice extra bits at the end of a brushstroke leading to the next brushstroke. The next brushstroke may also have an extra bit at the beginning to echo the previous one. The example opposite illustrates this characteristic.

Personal project using Tsao Shu

Writing Tsao Shu certainly requires a lot of skill, planning, and understanding of the Chinese language. However, there is nothing stopping you from having a go. A good word to start with is the word for "dragon." I think the Tsao Shu style illustrates the meaning wonderfully well – the brushstrokes look like a dragon on the move.

To write the word, you need to keep your brush moving all the time. Press where the brushstroke needs to be thick, and lift where it needs to be thin. You'll probably need to practice it many times to get used to writing the whole word.

You can write the word on anything. I wrote it on a T-shirt using fabric paints. When using these special paints, it is essential that you follow the manufacturer's instructions.

The "dragon" is supposed to bring strength and goodness.

LESSON 29 Kai Shu

"Kai" means "model" or "standard." It is generally believed that Kai Shu evolved from Li Shu because there were no records of Kai Shu until the Han Dynasty, when Li Shu was the main style of writing. However, it was not until the Tang Dynasty that Kai Shu become as popular as the other styles. This was the most prosperous period in the history of China, and literature and art were given great prominence. Scholars were hungry for ways to express themselves and wanted a style to distinguish themselves from the masses. Kai Shu is a very elegant and precise style of writing. Every brushstroke has a standard, and every word has a form. A script for perfectionists, Kai Shu was exactly what the scholars were looking for, and it quickly became a standard for achievement. Kai Shu is the style you will find in a Chinese dictionary.

Writing Kai Shu

The instructions for all brushstrokes in this book, from Lesson 1 through to Lesson 25, have been those for the Kai Shu style. As we have learned from these lessons, there are three key stages for writing a standard brushstroke:

Stage 1. Start with a small lift to position the brush, then a small press to get into the main body of the brushstroke.

Stage 2. Continue without stopping to write the main body of the brushstroke.

Stage 3. Press and lift to finish off.

Anatomy of the horizontal brushstroke and the dot in the Kai Shu style

These diagrams show how these basic brushstrokes, learned in earlier lessons, can be broken into the three stages described above.

Distinctive characteristics

1. Kai Shu is a very formal style. Each word has a standard form. There are strict rules not only for writing brushstrokes but also for the way in which words are formed.

2. Each word aims to be a square shape. There are strict rules to control the sizes of each unit of a word so that the final presentation looks balanced. No parts should be exaggerated or out of place.

3, Every brushstroke should be neat and simple. There is no link between brushstrokes, no simplification and no additions at either end of a brushstroke.

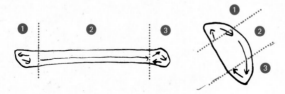

Personal project using Kai Shu

I once accompanied my mother on a retreat. In the room where we stayed, there was a ceramic water jug and a shallow bowl for drinking. The words "source of the fountain" were written on the jug, symbolizing the origin of strength and goodness, and the words for "valley of humility" were written inside the bowl. Every time I drank water from the bowl, I stared right into the words. Those utensils were designed to remind us that before receiving strength and goodness, one must show humility. I now have these words painted on a stoneware water jug and vase in my studio. The sayings, of course, could be written on practically any surface. Use porcelain paint, available from most art shops, to write on stonewares, but remember, always follow the manufacturer's instructions.

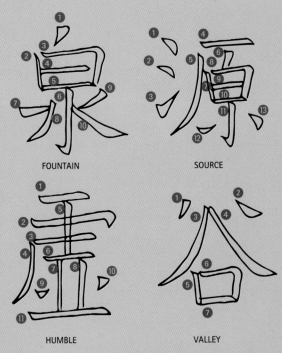

FOUNTAIN

SOURCE

HUMBLE

VALLEY

Writing words on stoneware vases makes them both attractive and unusual, especially when they carry a personal message.

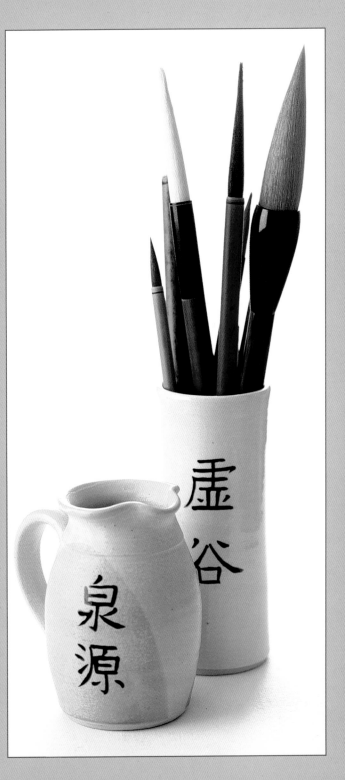

LESSON 30 Hsing Shu

"Hsing" means "running" or "fluent." Words in this style are very similar to those in Kai Shu—and many experts believe that Hsing Shu is a further development of Kai Shu from the Han Dynasty. One calligrapher once stated that Hsing Shu is in fact a speed-writing form of Kai Shu. I tend not to agree as, while the forms of words in Hsing Shu are definitely based on the formal Kai Shu script, Hsing Shu has developed into a freer and more active way of writing. Many of the practices of Hsing Shu have, in fact, moved closer to Tsao Shu. But although Hsing Shu has many similar features, it has the advantage of being more recognizable and more restrained than Tsao Shu. It therefore retains all the elegance of Kai Shu but also has some of the dynamic nature of Tsao Shu—making it acceptable for both daily and artistic use.

Writing Hsing Shu

While all the brushstrokes you have learned so far have been based on Kai Shu, all the words have been in the style of Hsing Shu.

It is now time to take a closer look at Hsing Shu. As mentioned before, every Chinese word has many forms, even within one style. Hsing Shu is a very flexible form of calligraphy; in fact, it is probably the most varied form.

Let's look at some of the most distinctive features of Hsing Shu. If you compare the Hsing Shu version of the word "rain" on page 115 with the same word in the other scripts, you will notice many of the features that make this style different. However, these features are not compulsory in writing Hsing Shu but are simply possible alternatives that show us the flexibility of this style.

Bear in mind that each word that follows in this lesson is one alternative of the actual word. For instance, the word "union" appears again on page 91 in a different form of the same style.

Distinctive characteristics

1. The majority of words retain the same structure as that used in Kai Shu, but the presentation is different. Brushstrokes are more angled, and some are emphasized for artistic purposes. This can be seen in my version of the word for "wood," on the opposite page.

2. Most brushstrokes are the pointed forms of the standard brushstroke. Step 1 of a standard brushstroke is therefore absent, and, as a result of this, corners are smoother and rounder. These can be seen in the brushstrokes in the word for "union," opposite.

3. Hsing Shu often uses dots to replace brushstrokes. See the words for "wood" and "correct," opposite.

4. Many practices have similarities to Tsao Shu. Some such similarities are illustrated with examples on page 126. Some of the brushstrokes are linked. Typical examples are the word "humble" and the joined strings of dots. Groups of dots can become a line in speed-writing. Tiny extensions appear at either end of brushstrokes as a result of writing at speed. See the word for "spirit."

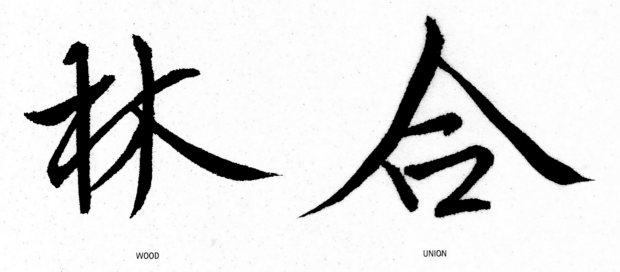

WOOD

UNION

This Hsing Shu version of the word "wood" (small forest) has more angled brushstrokes.

Brushstrokes of the word "union" in Hsing Shu style take the pointed form. Corner of the box is rounded.

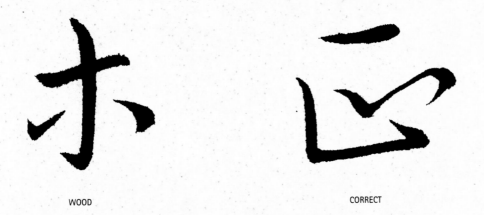

WOOD

CORRECT

"Wood" (material) and "correct" are two examples in Hsing Shu style with dots replacing the longer brushtrokes.

Similarities between Hsing Shu and Tsao Shu

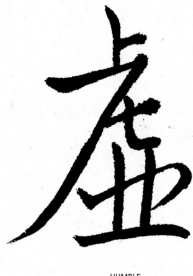

HUMBLE

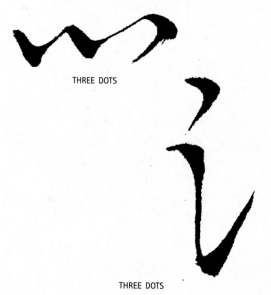

THREE DOTS

THREE DOTS

The two dots on the word "humble" are written linked together.

Three dots arranged horizontally or vertically are linked together in Hsing Shu style.

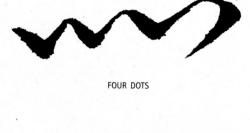

FOUR DOTS

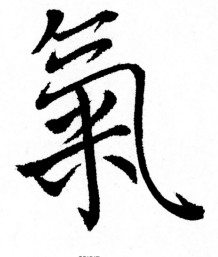

SPIRIT

FOUR DOTS

Four dots can be linked or written as a line.

"Spirit" is a typical example of a word with extensions at the end of brushstrokes.

Personal project using Hsing Shu

A display of writing can be found in most Chinese homes. This usually includes a centerpiece, which consists either of a painting or large-sized word, with a pair of writings, one of either size. The meaning of this triptych display reflects the principal beliefs of the family.

In this project, I made a typical household display; the finished result is shown overleaf, and the words are shown below. The center word means "humble" and "honest." The saying on the right can be translated as "I am honest through and through." The writing on the left means "My sleeves are empty so that even wind can pass through them"—this means the family is not open to bribes, which were traditionally hidden in the sleeves of the recipient. A family with these writings on their wall are simply declaring they are honest people.

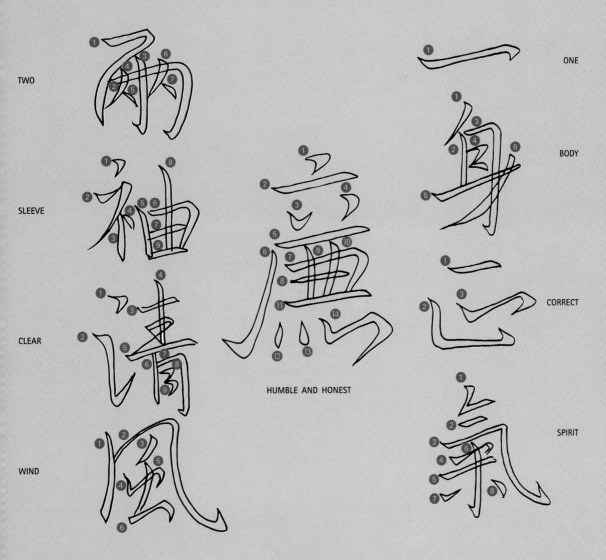

TWO

SLEEVE

CLEAR

WIND

HUMBLE AND HONEST

ONE

BODY

CORRECT

SPIRIT

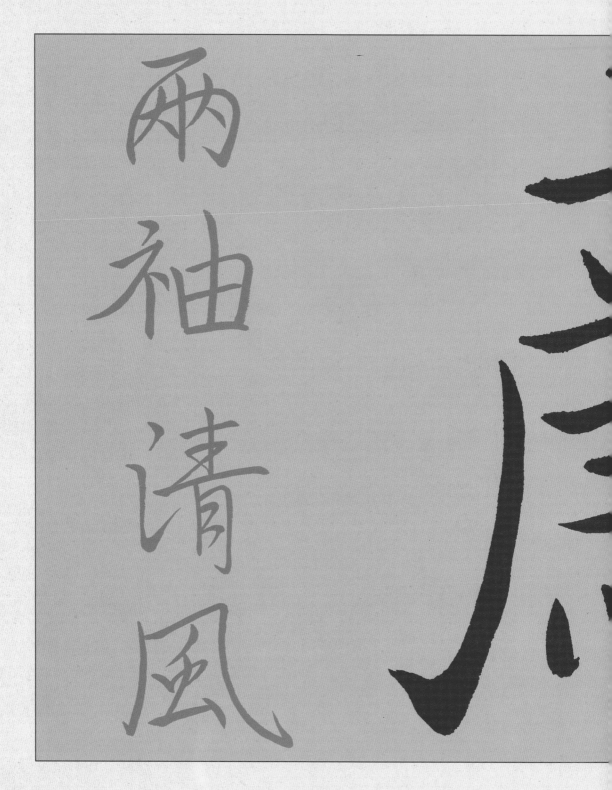

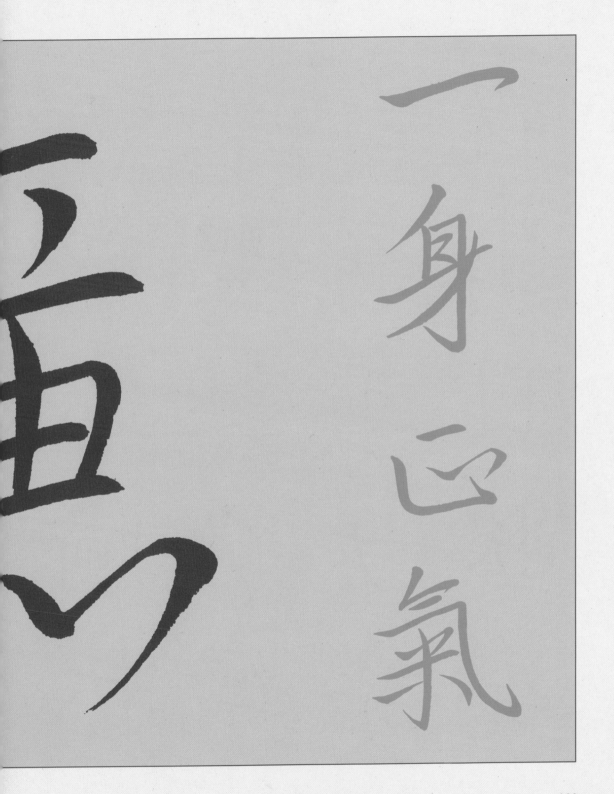

SHEET 5 Useful Greetings

祝

WISHING

Starting a Greeting Card

You would usually begin a card with the word for "wishing" and go on to add any of the following greetings on these two pages—all of which are in Hsing Shu script. The greetings can also be used on their own, without the word "wishing."

生
日
快
樂

HAPPY BIRTHDAY

新
年
快
樂

HAPPY NEW YEAR

聖
誕
快
樂

HAPPY CHRISTMAS

旅
途
愉
快

BON VOYAGE

永　母　早　考
結　子　日　試
同　平　瘁　成
心　安　瘉　功

YOUR UNION (ENGAGEMENT,　MOTHER AND BABY　SPEEDY RECOVERY　GOOD LUCK WITH
MARRIAGE) IS FOREVER　BOTH WELL　FROM ILLNESS　YOUR EXAMS
(BIRTH OF A BABY)

Seven
Mounting a Xuan Paper Artwork

Calligraphy paper becomes rippled and uneven when you write or paint on it. In order to present your artwork in an attractive way, it is therefore necessary to smooth out the paper and mount it on a heavier backing material.

春眠不覺曉

處處聞啼鳥

夜來風雨聲

花落知多少

Mounting a Xuan Paper Artwork

Xuan paper is very thin, so it always needs to be attached to thicker paper before it can be framed. The trouble is that writing with ink on Xuan paper creates wrinkles, which can then turn into creases if you press the paper onto the backing material. This would obviously ruin the final presentation of the artwork. The aim of the mounting process, therefore, is to get rid of the wrinkles at the same time that it is bound onto the heavier paper.

The traditional method of mounting Chinese calligraphy has been used for a long time. It is an art in itself, requiring experience and skill. Although improvements have been made and new tools have been invented to make the method easier to master, it is still a complicated technique that puts many people off.

The process involves wetting the artwork and using rice starch to bind it to the heavier backing paper. Handling wet Xuan paper requires great care. Although the gum in the Chinese ink and Chinese colors should make them permanent on paper, they still tend to run when wet. Most mounting masters have learned the art of touching up Chinese artworks, but this is yet another skill that needs to be laboriously learned.

I have been teaching my pupils the traditional method of mounting for a long time, but for years I have been searching for an alternative to make the mounting process easier and better adapted to the materials available nowadays. I have spent a considerable amount of time developing and perfecting the method. Every summer I run classes to teach mounting, and many pupils confirm that they find this method very successful. I would therefore love to share it with you as a perfect ending to this book.

The mounting process
You will need:

- Xuan paper artwork
- Metal rule
- Soft pencil
- Sharp craft knife or scissors
- Piece of thick cardboard at least 0.8 in (2 cm) bigger than the artwork all the way round. The cardboard should preferably be around $1/40$ in (0.5 mm) thick with a matt finish. I use acid-free cardboard for quality and longevity.
- A1 size sheets of newsprint. Allow 10 pieces for each artwork; fewer if the artwork is small.
- Multi-purpose tack
- Spray mounting adhesive
- Face mask
- Two heavy boards
- Paper towels to clean the heavy boards
- One heavy weight, or two big books
- Hand-sprayer filled with clean water

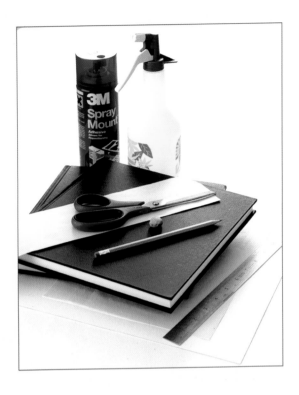

If your artwork is heavily creased, it is better to stretch it before mounting. To do this, lay the artwork upside down on a piece of clean newsprint. Spray it with clean water. If there are severe creases, spray a bit more water. Stretch the artwork slightly, then turn it the right side up and lay it flat on clean newsprint to dry.

1. Decide how big you want your finished artwork to be. It is easier to start with a rectangular artwork. Add at least 0.8–1.2 in (2–3 cm) all round to these measurements (this allows for overlapping with card mount if framing), then draw straight lines with a pencil on your artwork to confirm the size and shape. Cut off excess paper with a sharp pair of scissors.

2. Lay the artwork on the cardboard, and mark the outline in pencil. Mark another rectangle around this that is at least another 0.8–1.2 in (2–3 cm) bigger all the way round. Cut out the cardboard along this new rectangle with a sharp knife or scissors and a metal ruler. Label the top edge so that you will know where to place the artwork later on. If you are mounting more than one artwork at a time, also note the title of the artwork to avoid mix-ups. I used an ink marker for this illustration because I wanted to show the markings clearly, but it is preferable to use pencil so the lines can be erased later.

3. Cut or tear a piece of newsprint into long strips about 4 in (10 cm) wide. Fold over one edge of each strip lengthways to create a straight edge. Make enough strips to cover the four edges of the cardboard.

4. Stick small bits of multi-purpose tack along the outer edge of the rectangular pencil line on the cardboard at about 2–2.4 in (5–6 cm) intervals.

5. Line up the folded sides of the newsprint strips with the outline markings of the artwork on the cardboard. Press the strips down onto the multi-purpose tack to cover the space around the cardboard, leaving only the space for the artwork exposed.

6. Using the paper towel, clean the two heavy boards to remove any dirt. Lay one on a flat surface and cover with two layers of clean newsprint.

7. Lay another sheet of clean newsprint on a flat surface and place the artwork upside down on this. Spray clean water lightly using a fine spray from the hand sprayer. Do not wet the artwork too much. In places where there are creases in the Xuan paper, sprinkle a little more water. Spraying water sparingly onto the artwork relaxes the paper so that it can be stretched when it is mounted on the cardboard to remove the wrinkles.

8. Place the damp artwork onto the newsprint on the heavy board. Cover it with two more layers of newsprint and place the other heavy board on top. Put a heavy weight on top of the board. This will allow the newsprint to absorb some of the moisture in the Xuan paper. The board and the weight will keep the Xuan paper nice and flat.

9. Spray the exposed area of the cardboard evenly using the can of spray adhesive. Ensure the room is adequately ventilated and that you wear a suitable mask as you do this.

10. Then remove all the newsprint and multi-purpose tack that have been used to protect the edges of the cardboard from the adhesive. Lay the cardboard on a flat surface.

11. Remove the weight and the heavy board from on top of the artwork. Transfer the artwork to the cardboard, lining it up exactly with the pencil marks you made earlier. Do not move onto the next stage until you are sure that the artwork is in just the right place.

12. Place a piece of clean newsprint on top of the artwork and press lightly from the center outward. Lift the newsprint and see if there are any creases. If there are, the artwork can be lifted at this stage and laid again. Bubbles are all right because these can be removed by pressing. Once you have lifted the newsprint, discard it and swap to a clean sheet, as it may be carrying a bit of ink or color that could smudge the artwork.

13. When there are no creases, and the artwork is in the right place, place a clean sheet of newsprint on top of the artwork and press hard with your palm. Start from the center and work your way outward. Make sure you press on every area of the artwork. The artwork is now properly mounted.

14. If the artwork is still damp, sandwich it between clean newsprint sheets and heavy boards until it is completely dry.

Gallery

Chinese calligraphy is not only a tool for communication—it is a form of artistic expression. On the following pages are examples of the many different ways in which calligraphy can be used. Hopefully, they will fire your imagination to create your own artistic works.

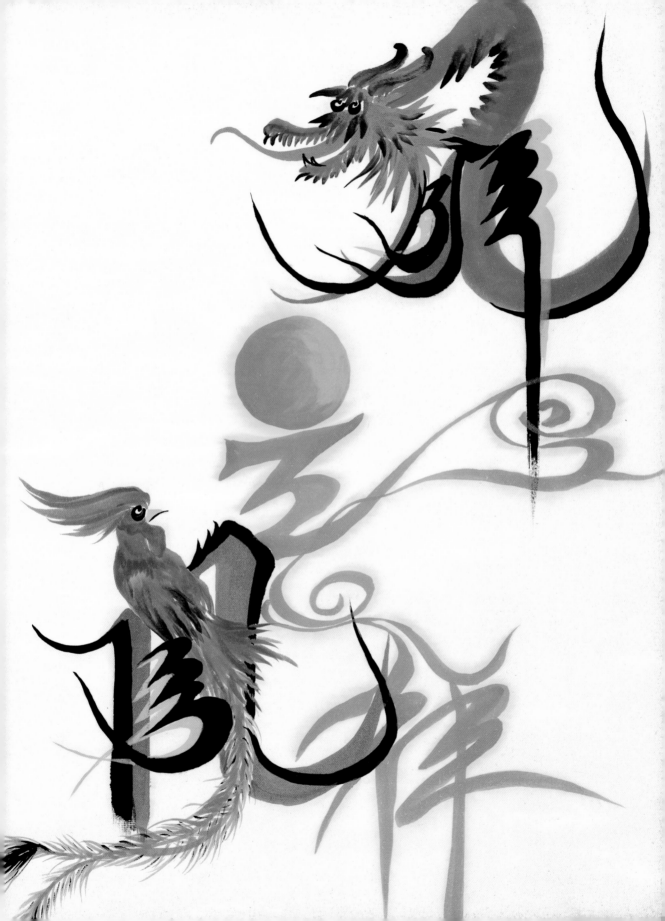

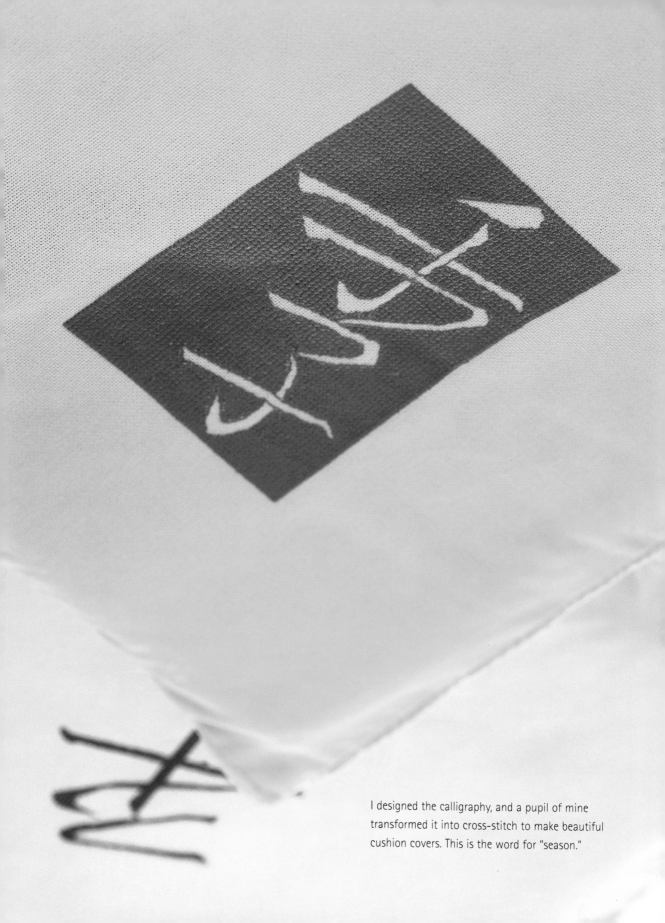

I designed the calligraphy, and a pupil of mine transformed it into cross-stitch to make beautiful cushion covers. This is the word for "season."

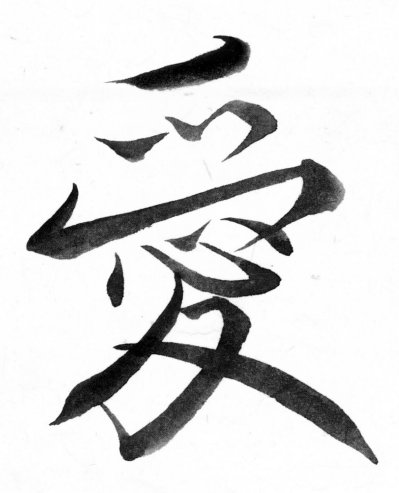

This is the word "love," written using a two-color
technique that is frequently used in Chinese painting.
I loaded the brush with red watercolor and then dipped
the tip into the blue color before I wrote the word.
The resulting brushstrokes have a two-color effect.

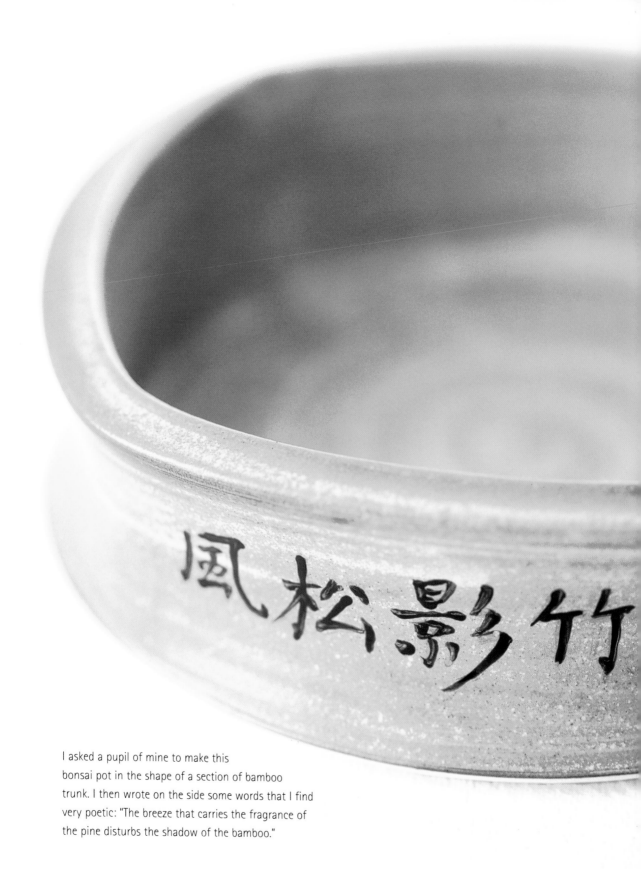

風松影竹

I asked a pupil of mine to make this
bonsai pot in the shape of a section of bamboo
trunk. I then wrote on the side some words that I find
very poetic: "The breeze that carries the fragrance of
the pine disturbs the shadow of the bamboo."

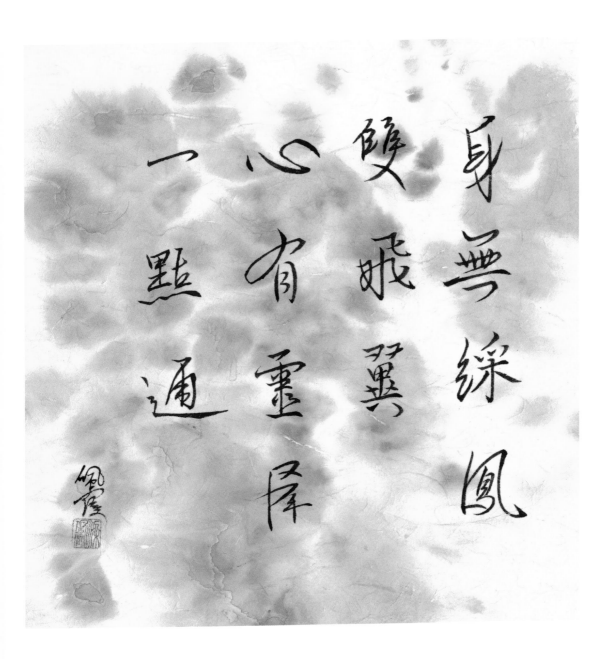

身無綵鳳
雙飛翼
心有靈犀
一點通

This is a love poem:
"I regret that I do not have a pair of wings
like the phoenix so that I can fly to you.
But our hearts are linked by our strong feelings."

These words say, "Have the virtues of an honest gentleman." I loaded the brush with green watercolor and dipped the tip into ink. When I wrote, I kept the brushstrokes thin so that the tones would gradate from dark to light.

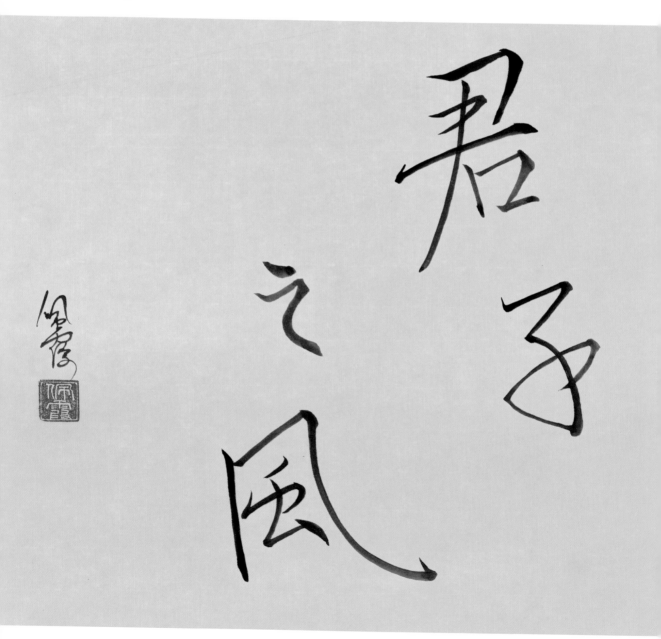

Ancient Chinese
calligraphy is believed
to have developed
from pictorial forms.
"Picture calligraphy"
is an expression of
this concept—where a
word is made up of
partly picture and
partly elaborated
calligraphy. The words
are designed to
emerge from the
picture. My artwork
shows four words
that mean: "The
dragon and the
phoenix are signs of
goodness and
blessing."

誰家玉笛暗飛聲
散入春風滿洛城
此夜曲中聞折柳
何人不起故園情

I wrote this Chinese poem about being homesick on Xuan paper with a bamboo print background.

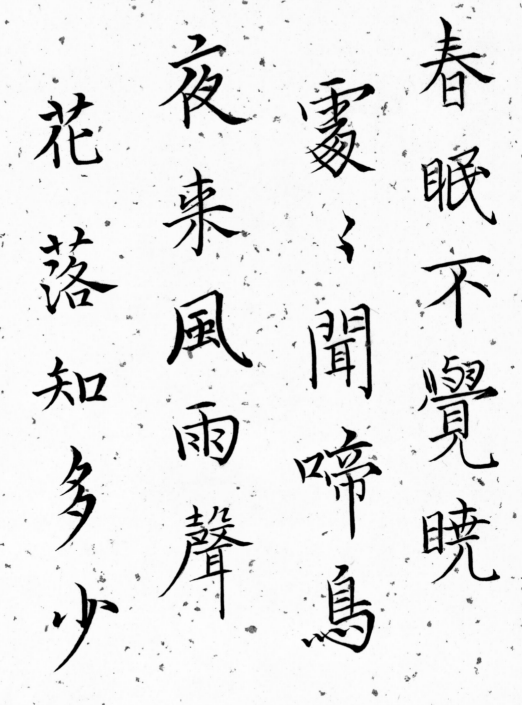

春眠不覺曉
處處聞啼鳥
夜來風雨聲
花落知多少

I wrote this Chinese poem about spring
on speckled gold paper.

This pair of Chinese writings uses blue watercolor instead of ink. The words, reading right to left, mean:

"The moon shines through the pine tree

Clear water runs through the rocks."

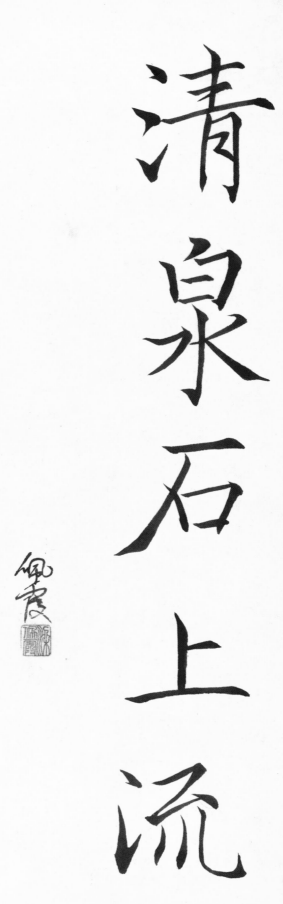

Such pairs of writings are popular for wall-hangings; however, there are strict rules for their composition. The two sayings have to be balanced in words, ideas, and sounds. Each one is mounted separately, but displayed side by side.

Glossary

Bamboo slat
Before paper was invented, bamboo was cut into long strips, known as slats, and used as writing tablets. Short messages could be squeezed into one slat. If more than one slat was used, they were usually bound by string to form a mat-like structure that could be rolled up for transport.

Basic brushstrokes
There are eight basic brushstrokes. They are horizontal brushstroke, vertical brushstroke, dot, hook, press and lift upward, press and lift downward, diagonal brushstroke to the left, and diagonal brushstroke to the right. Each Chinese word is made up of one or more of these brushstrokes.

Big Writing
Size of calligraphy where each word is at least 2 x 2 in (5 x 5 cm). See also *Sizes in Chinese writing*.

Black hair
One of the three types of hair used for making Chinese brush tips. Black hair brushes use the hair of hog, horse, squirrel, racoon, and some other animals. Usually dyed black, this type of hair is the toughest and is the one most suitable for expressive artwork. See also *Hair*.

Brown hair
One of the three types of hair used for making Chinese brush tips. Typically, brown hair brushes are fox, rabbit, or wolf hair, dyed brown. Also known as tough hair. See also *Hair*.

Brush mat
Brushes for Chinese calligraphy are traditionally stored by being rolled up in mats made out of thin sticks of bamboo.

Brush tip size
Sizes of Chinese brushes for calligraphy are categorized according to the length of their brush tips. There are usually three sizes: short, long, and extra long.

Chinese brush
A Chinese brush is made up of a handle and a brush tip. The handle is traditionally made of bamboo, although some modern ones are made of plastic. The brush tip is usually made of animal hair.

Chinese New Year
The first day of a Chinese year falls on a new moon between January and March. The date is determined by a system thousands of years old.

Chinese writing book
The earliest form of a Chinese writing book is made up of a long sheet of paper attached to the front and back covers. The paper is folded like a concertina to form pages.

Chuan Shu
Chuan Shu is believed to be the earliest developed form of Chinese writing. It is still used today, but more for artistic purposes. It is, however, still widely used for carving seals. See also *Five styles of Chinese calligraphy* and *Seal script*.

Clerkly script
Li Shu is sometimes called "clerkly script" because at the height of its popularity, it was used by clerks for official recordings. See also *Li Shu*.

Cotton paper
Cotton paper is a type of absorbent paper made mainly from cotton with tree-bark and bamboo. It is widely used for calligraphy, painting, and craft.

Diagonal brushstroke to the left
This is one of the eight basic brushstrokes of Chinese calligraphy. See also *Basic brushstrokes*.

Diagonal brushstroke to the right
This is one of the eight basic brushstrokes of Chinese calligraphy. See also *Basic brushstrokes*.

Dot
One of the eight basic brushstrokes of Chinese calligraphy. See also *Basic brushstrokes*.

Dynasty
When a warrior overturned an emperor and set up his own kingdom, the period ruled by him and his descendants was called a dynasty.

Elbow movement
These are long movements made by rotating the elbow. It is useful for writing long brushstrokes and big words.

Extra long tip
This is the longest size of a brush tip. See also *Brush tip size*.

Five styles of Chinese calligraphy
The five styles of Chinese calligraphy are Chuan Shu, Li Shu, Tsao Shu, Kai Shu, and Hsing Shu.

Four sheet
A measurement of thickness of Chinese paper. "Four sheet" is the thickest grade that is usually used. See also *Thickness*.

Goat's hair
Goat's hair is a type of soft hair for making the brush tips of Chinese brushes. See also *Soft hair*.

Golden rules
There are five golden rules. They are used as guidance to the order of writing each brushstroke in a Chinese word.

Grass script
The Chinese word "grass" also means "speed." Tsao Shu is written at speed and is sometimes called "grass script." See also *Tsao Shu*.

Gum
Gum is added to Chinese ink so that it is permanent when it is dry.

Hair
There are three types of hair used for Chinese brush tips: soft hair, brown hair (tough hair), and black hair.

Hook
Hook is one of the eight basic brushstrokes of Chinese calligraphy. See also *Basic brushstrokes*.

Horizontal brushstroke
This is one of the eight basic brushstrokes of Chinese calligraphy. See also *Basic brushstrokes*.

Hsing Shu
Hsing Shu is one of the styles of Chinese calligraphy. It is the most popular style used in modern Chinese writing. See also *Running script* and *Five styles of Chinese calligraphy*.

Ink
Ink is a mixture of gum and the soot derived from burning wood and seeds.

Ink stick
Made by pouring a mixture of ink and gum into molds and letting the liquid dry. The ink stick is ground with water against a surface, like that of an inkstone, to produce ink.

Inkstone
Used in ink preparation for grinding the ink stick. An inkstone is made from a natural stone that looks similar to slate but is harder. Inkstones are often decorated with elaborate carvings.

Kai Shu
It is one of the five styles of Chinese calligraphy. Kai Shu is the standard style used for learning brushstrokes. Every word has a strict pattern to follow. It is the script used in the Chinese dictionary and in printed documents. See also *Pattern script* and *Five styles of Chinese calligraphy*.

Large brush
A term used by the author for teaching purposes. It refers to the two following brushes: the goat-hair, short tip large script; and goat-hair, long tip large script.

Large Script
Words of Large Script are bigger than 1 x 1 in (2.5 x 2.5 cm). See also *Sizes in Chinese writing*. It is also a name of a big-size brush suitable for writing Large Script. Refer to *Large brush*.

Level
A term used for teaching. Levels are the vertical partitions of a word.

Li Shu
This is one of the five styles of Chinese calligraphy. It was used for official recordings at the height of its popularity. See also *Clerkly script* and *Five styles of Chinese calligraphy*.

Lift technique
Technique used in writing or painting in order to make brushstrokes thinner. As a brush is lifted, its tip will gradually come back to a point to create a thinner brushstroke.

Liquid ink
Ink manufactured for immediate use, without the need for preparation. Convenient alternative to grinding solid ink sticks. The quality of this bottled ink, nowadays, is good enough for use by professional artists.

Long tip
One of the sizes of Chinese brush tips. See also *Brush tip size*.

Medium brush
Medium brush is a name of a brush between the size of a small brush and a large brush. It is used for writing both the Small Script and the smaller versions of Large Script. See also *Small Script*, *Large Script*, *Small brush*, and *Large brush*.

Meng Tian
The man who invented the modern version of the Chinese brush around 250 B.C.

Mixed hair
A Chinese brush tip can be made with a mixture of soft hair and tough hair. There are two types of such brushes. One type has the soft hair to make up the outer part and tough hair in the center. The other type has soft hair in the center and tough hair around it.

"Moon Palace"
This is a type of absorbent paper of "two sheet" thickness. It was originally made by the Japanese but is now also made in China and Taiwan.

Mounting
Writing and painting on the absorbent paper creates wrinkles. Mounting is the process to smooth the wrinkles and to adhere the absorbent paper onto a thicker backing material.

Mulberry paper
This is a type of absorbent paper made with mulberry tree bark. There are two varieties, one with texture created using rough fiber and one that is smooth.

One sheet
This is the thinnest grade of Chinese paper. See also *Thickness*.

Opening a brush
A new brush has its tip heavily gummed together for presentation. The process of removing this gum so that it can be used is called "opening the brush."

Pattern script
Words of Kai Shu have very strict patterns for learning. It is considered to be the standard for learning brushstrokes. Therefore, Kai Shu is sometimes called "pattern script." See also *Kai Shu*.

Pictorial forms
It is generally believed that Chinese writing began with pictures and developed through thousands of years to the present writing forms. For example, the word "bird" would have originally simply been a drawing of a bird.

Picture calligraphy
An old art form that combines painting and calligraphy to create artwork.

Press and lift downward
This is one of the eight basic brushstrokes of Chinese calligraphy. See also *Basic brushstrokes*.

Press and lift upward
This is one of the eight basic brushstrokes of Chinese calligraphy. See also *Basic brushstrokes*.

Rabbit hair
Rabbit hair is one type of "tough hair." See also *Tough hair* and *Hair*.

Reversing technique
This is a technique used when writing in Chuan Shu style to achieve a round beginning to a brushstroke. It is usually represented by the symbol ⌒ in instructions.

Rice starch
Rice starch is a glue made with rice flour and water. It is used in the process of mounting Xuan paper artwork. Rice flour intended for mounting should never be used for cookery because insecticide may have been added to it.

Running script
In writing Hsing Shu, the emphasis is on maintaining the same mood throughout a piece of writing. In order to achieve that, the artist has to keep moving with moderate speed so that he or she will not lose the feeling inspired by the content. Such action is compared to running. See also *Hsing Shu*.

Seal
A seal is a personal or official stamp. The name of the person or the official representation is carved onto a small piece of ivory, stone, jade, or wood. Chuan Shu is the favorite style of calligraphy carved on a seal.

Seal script
Another name for Chuan Shu—a favorite style of calligraphy for engraving seals. See *Chuan Shu*.

Short tip
This is the shortest size of a brush tip. See also *Brush tip size*.

Sizes in Chinese writing
Chinese calligraphy is usually categorized into three different sizes—Small Script, Large Script, and Big Writing.

Small brush
This is a term used by the author for teaching purposes. It refers to the following small brushes: short tip, wolf hair, Small Script; or 50% rabbit hair and 50% goat hair.

Small Script
The size of each word in Small Script is 1 x 1 in (2.5 x 2.5 cm) or less. See also *Sizes in Chinese calligraphy*. Also the name of a brush suitable for writing Small Script. See also *Small brush*.

Soft hair
One of the three types of hair used as tips on Chinese brushes. These may be made with goat hair, lambswool, goose feathers, or chicken feathers. They are are usually bleached white. See also *Hair*.

Style of Song
A type of Chinese brush. Several Emperors of the Song Dynasty (A.D. 960–1127) were distinguished calligraphers, and many new calligraphy brushes were invented in this period for royal use. They are reproduced today in the same style.

Thickness
The thickness of Chinese paper is usually graded as "one sheet," "two sheet," "three sheet" and "four sheet, "according to its thickness. One sheet is the thinnest, and four sheet the thickest.

Three sheet
A grade of thickness of Chinese paper. See also *Thickness*.

Ti brush
Ti brush is a big brush used for big and expressive artwork.

Tough hair
One of the three types of hair used for making Chinese brush tips, also known as brown hair. See *Brown hair*.

Tsao Shu
This is one of the five styles of Chinese calligraphy. See also *Grass script* and *Five styles of Chinese calligraphy*.

Two sheet
This is a grade of thickness of Chinese paper. See also *Thickness*.

Unit
This is a term used by the author for teaching purposes. Units are horizontal partitions of the word.

Vertical brushstroke
This is one of the eight basic brushstrokes of Chinese calligraphy. See also *Basic brushstroke*.

Wang Xi Zhi
Wang Xi Zhi (A.D. 321-361) was a very talented calligrapher and his works greatly influenced the development of Chinese calligraphy. He was responsible for popularizing Hsing Shu.

White goose
A type of soft hair brush made with goose feathers. See *Soft hair*.

Wolf's hair
This is a type of tough hair used for brush tips. See also *Tough hair* and *Hair*.

Wrist movement
Wrist movements are small movements made by rotating the wrist. They are useful for writing small brushstrokes and Small Script.

Xuan paper
A thin, absorbent paper, traditionally made in the city of Xuan. It is the most commonly used type of paper in Chinese calligraphy.

Suppliers

US

Artistic Chinese Creations
13022 Dean Street
Tustin
CA 92780
USA
Email: info@artisticchinesecreations.com
Website: www.artisticchinesecreations.com

EChinaArt Store
Tel: 718 938 6588
Website: www.echinaart.com

Flax Art & Design
240 Valley Drive
Brisbane
California 94005 1206
Tel: 800 352 9278
Website: www.flaxart.com

House of Rice Store
3221 North Hayden Road
Scottsdale
AZ 85251
USA
Tel: 480 947 6698
Fax: 480 947 0889
Website: www.houserice.com

The Phoenix Shop
Highway One
Bigsur
CA 93920
USA
Tel: 831 667 2347
Website: www.nepenthebigsur.com

UK

Blots Pen and Ink Supplies
14 Lyndhurst Avenue
Prestwich
Manchester, M25 0GF
UK
Tel: 0161 720 6916
Website: www.blotspens.co.uk

Heaton Cooper Art Materials
Heaton Cooper Studio Ltd
Grasmere
Cumbria, LA22 9SX
UK
Tel: 015394 35280
Fax: 015394 35797
Website: www.heatoncooper.co.uk

Jackson's Art Supplies
1 Farleigh Place
London
N16 7SX
UK
Tel: 0207 254 0077
Fax: 0207 254 0088
Website: www.jacksonsart.com

Manuscript Calligraphy Pen Company
Highley
Nr Bridgenorth
Shropshire
WV16 6NNa
UK
Tel: 01746 861 236
Fax: 01746 862 737
Website: www.calligraphy.co.uk

Index